NICK CROWE
Commemorative Glass

Nick Crowe: Commemorative Glass

ISBN-10 0-9550478-0-3
ISBN-13 978-0-9550478-0-0

Limited edition of 1000

Published by
Cornerhouse
70 Oxford Street
Manchester
M1 5NH
United Kingdom
Telephone: +44 (0) 161 228 7621
Fax: +44 (0) 161 200 1506
exhibitions@cornerhouse.org
www.cornerhouse.org

Reg No 1681278 England
VAT Reg No 383410758
Reg Charity No 514719

Nick Crowe: Commemorative Glass
is published on the occasion of the exhibition and
tour organised by Cornerhouse, curated by Kathy
Rae Huffman

Commemorative Glass will tour to

16 February – 31 March 2007
CCA The Centre For Contemporary Arts
350 Sauchiehall Street
Glasgow G2 3JD

3 March – 5 April 2008
University of Hertfordshire Galleries:
Margaret Harvey Gallery
St Albans AL1 3RS
and
The Art and Design Gallery
College Lane, Hatfield AL10 9AB

Texts by Godehard Janzing, Esther Leslie and
Marcus Verhagen

Godehard Janzing's text translated from German
by Ben Carter

Foreword by Kathy Rae Huffman

Edited by Kathy Rae Huffman

Copy-editor: Helen Tookey

Design: Alan Ward, www.axisgraphicdesign.co.uk

Photography: David Williams, except pp. 16, 19, 20
(top), 26 (top), 27–33 the artist

Typeset in John Baskerville by Stormtype.com and
Vista by Emigre.com

Printed and bound by: Ediroiale Bortolazzi Stei,
Italy

Distributed by:

Cornerhouse Publications
70 Oxford Street
Manchester
M1 5NH
United Kingdom
Telephone: +44 (0) 161 200 1503
Fax: +44 (0) 161 200 1504
publications@cornerhouse.org
www.cornerhouse.org/books

Exhibition funded by:

 The Henry Moore Foundation Esmée Fairbairn FOUNDATION

Cornerhouse funded by:

COVER
Damaged phone box on Rüdigerstrans, Berlin

Contents

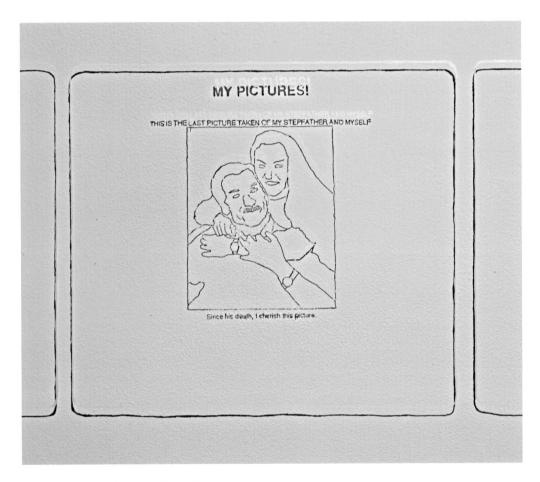

Margo Barbour's Web Site, 1998 (detail)

Foreword:
Commemorative Glass

KATHY RAE HUFFMAN

Nick Crowe's art-making encompasses a range of strategies which include the exploration of the role of technology and its contingent effects on everyday life. Widely known as a multi-media artist, Crowe's practice eludes categorisation. He was engaged in setting up significant artist-led initiatives in Manchester during the 1990s, and has continued to contribute to cultural life in the region, working on the *Manchester Pavilion* project at the 2003 Venice Biennale as well as co-curating *Artranspennine03*, a trans-regional exhibition of public art, with his collaborator Ian Rawlinson. He regularly contributes critical perspectives on art practice, and has written in journals, books and art magazines. He has also developed several publication projects and online works that critique political systems and challenge artistic institutions. In 2004, Nick Crowe was awarded an AHRC fellowship in the Creative and Performing Arts to research the aesthetic possibilities of industrial glass-processing techniques in contemporary visual art, which has allowed him to expand his cross-disciplinary ideas and create monumental new works. *Commemorative Glass* surveys Crowe's evolving practice concerned with the immateriality of the Internet, repositioning it within the tradition of craft and the artistic manipulation of materials.

Crowe developed a specific interest in the Internet around 1995, and his curiosity about the Net was a continuation of his interest in public space, informed by his early collaborative performance work with the group Index. Using the Internet for low-tech activity, as the source for found content, and as a site for the appropriation of political and cultural propaganda, he developed a clear Net aesthetic, and established himself as one of the UK's most productive and interesting new media artists. His use of glass as an artistic material for topical and political content could be considered a diversion from his digital work, but it evolved concomitantly, during the production phase of *The Citizens* (1999). While painstakingly rendering drawings of personal home pages for the book, Crowe produced his first Internet-sourced drawing on glass in 1998: *Margo Barbour's Web Site.* The image of this website was hand engraved by Crowe onto a sheet of float glass, with the resulting drawing visible only as a shadow, a negative projection on the surface behind the glass. By using the same material interface as the computer screen, Crowe found a way to bring together his disparate interests. A material taken for granted by most people, glass afforded him the opportunity to explore industrial technology in conjunction with object-making, to explore drawing in conjunction with cultural critique.

Commemorative Glass is part eulogy, part investigative act. In this exhibition, Crowe's work draws our attention to the human agency which consciously shapes the Internet as a communicative environment, by investigating its social and political aspects. His research and practice requires a continuous search of its curious and widely diverse content, its various interfaces and platforms. A result of this process, Crowe has amassed an enormous collection of personal sites that express individual viewpoints that deserve wider attention. He has illuminated and memorialised many of these lone "home pages", a disappearing form in the constantly shifting and increasingly commercialised data space we know as the World Wide Web.

His works on glass test its sometimes quirky physical limits as an art medium. One of Crowe's first works in glass to generate critical interest was *The New Medium,* a suite of 15 engraved glass panels that explore funereal culture on the web. Crowe took the very personal virtual messages that he found on the now defunct site 'Virtual Heaven' one step further, and engraved them on glass – as a transparent commemorative plaque visible only as a shadow. Using the same engraving technique, Crowe continued to investigate the evolution and development of the Net, creating works that explore its organisational structures, its economic consequences and, latterly, its increasing use as the means by which governments and non-governmental bodies seek to direct public opinion.

Not all the subjects and issues Crowe works with are Net specific. Some topics are already the focus of commemoration, others may well give rise to future memorials, and some perhaps, may never be deemed worthy of a commemorative gesture. Among his works not derived from the Internet is *Common Occurrences*, a work of five drawings on glass that memorialise children's drawings. These found sketches, simple and shocking, contradict an assumed innocence. *Recent History* is another series of five engraved glass plates that sit on a single shelf; the images use the 1960's children's magazine *Bo Bo Bunny* as their source, and depict the idealised domestic scenarios that prejudiced a generation of baby boomers, with ideals that were impossible to achieve. Moving into an unknown future, he created *The Family Tree of Zainab Duranthrrial Sadik Llthnnnztsol: The First Martian Martyr* which confronts the uniqueness of an inter-species pedigree, and is a memorial to a half-human, half-Martian female who died on Mars in the year 2226.

Underpinning all these works is Crowe's cultural investigation into the industrial use of glass, a material often associated with fragility and transparency. In her text *Glass and Hope*, cultural critic Esther Leslie lays out the fascinating history of the political and cultural importance of glass, and its role in social urban organisation from the nineteenth century onwards. She shows how, from the early 1800s, glass opened up social interaction in revolutionary ways, with the public 'no longer behind closed doors and solid walls'. Modernist architects, with their own moral and political agenda, developed their philosophy of the skyscraper as a new corporate world of glass and steel – before any such building was actually constructed. Leslie's reflections on the writings of cultural theorist Walter Benjamin and on those of Paul Scheerbart, an early twentieth-century architectural theorist, bring us into the era of Utopian vision and the Industrial Age, a period in which glass production was an important industry in northwest England.

The sculptural glass objects Crowe constructs are presented alongside his hand-engraved drawings and installations. His earliest sculptural work, A *Glass Menagerie* was created by applying heat to an engraved sheet of glass until it cracked, then reapplying heat to the broken fragments until they cracked again, and so on. It was an investigative process, in which a range of shapes evolved (some seem to take on the form of birds) which were then displayed on the original sheet from which they were broken. Crowe accredits this process to the culture of glass *objects d'art*, to which he is attracted. Newer sculptural objects presented in the exhibition include the small but powerful *Oh Xmas Tree!*, built up from broken and UV-bonded automotive windshield glass, and the large scale work *The Campaign for Rural England*, for which Crowe deliberately shatters the glass panes of a bus shelter, fabricated from English Oak, creating a memorial that challenges assumptions

about dangerous urban life and rural safety. These pieces not only demonstrate the physical properties of glass, but also use it to create objects that give an account of social presence and its wider-ranging cultural significance. *The Campaign for Rural England* brings the national British issue of 'rural vs. urban' into a confrontational position as art in the gallery, where it can be critically debated and explored as form and content. Both works are suggestive of yobbish anti-social urban behaviour, which through their antisocial behaviour produce the material (broken glass) that Crowe finds beautiful.

The Beheaded, a second major new work, examines the persistence of an ancient form of ritual killing in the contemporary context of the twenty-first century. This work is thoughtfully discussed by Marcus Verhagen in his text *On Looking Back through Sheets of Glass*. His analysis contextualises this large, sharply illuminated and slowly rotating mobile. The shadows and reflections create the disembodied spirit of the dead. Verhagen discusses and contrasts several works in the exhibition which derive content from the Internet.

Operation Telic, a discrete series of scenarios depicting British soldiers in Iraq, examines the exploitation of the web as a propaganda tool through the controlled communication strategies of the British military. The numerous visual descriptions of the occupation of Iraq are available freely to view on the Net. Godehard Janzing's text »This is Propaganda« describes the use of the source material from the MOD website, as propaganda, and the way in which the quoted images appear as luminous green scenes in which the lights embedded into the work shows up Crowe's diamond-point engravings. This colouration of glass features again in *Memorial to the Red-Green Alliance*, which takes a critical look at recent European political life. This compact sculpture, which sets smashed automotive glass against an emptied Lavazza Rosso coffee packet, speaks of the uneasiness between social activism and the cappuccino culture of liberal social democracy.

Crowe acknowledges the fragility of glass, and the strength of glass, with the work *Computer Spy*, a memorial to an aggressive software pop-up advertisement. He fired an air pellet into a plate of glass (twice), to produce a metaphorical set of 'spy' eyes, giving little comfort in any promised protection against subversive hackers. Crowe's unshakable connection to the Internet – an artist's environment and site for unconventional exploitation, subversion and intervention – provided the content for *27 Broken Windscreens*, which makes use of gif and jpeg images sourced from a Google image search. Crowe created this time-based visual portrait of the common urban occurrence resulting from vandalism, highway accident, or other malicious behaviour. He then places his gleaned content back online in edited form onto the website *YouTube*. The five minute 'animation' is a reminder that the Internet remains a source of extreme diversity, as well as a democratic platform for communication and collaboration. This brilliant recontextualisation gives dynamic evidence of Crowe's skilfulness to reference the next generation of Net critique. *Commemorative Glass* looks at a familiar industrial material as the form and content to create new connections, associations, and visualisations. Crowe's research has resulted in a highly charged conceptual experience of media, art and information culture.

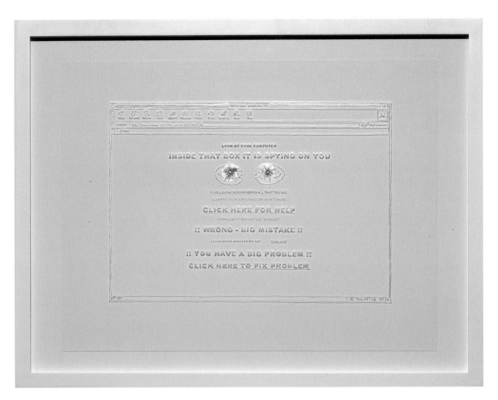

Computer Spy, 2005
June Becher, 2003

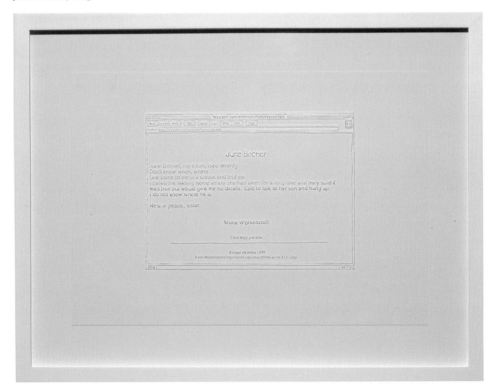

Glass and Hope

ESTHER LESLIE

Utopia is a dreamt location. It is imagined into a space, usually identical with the one that its author occupies. But what is utopia's time? Utopias are future worlds, but each utopia bears the outlines of its moment of writing. Utopias are brought into being negatively, against their moment, but are none the less formed by it. There is a unifying characteristic of many utopias (and indeed dystopias) from the nineteenth century onwards. In some way or another the currently achieved state of technological development frames the utopia, and so developments along the same lines are envisaged. This means that utopia's time is, at least in part, present time. In a sense, a utopia can only come into being once its technological preconditions are already in place, or almost in place. Marx identified the impulsion of revolution in this way: humanity 'sets itself only such tasks as it is able to solve, since closer examination will always show that the problem itself arises only when the material conditions for its solution are already present or at least in the course of formation'. [1]

In the last century utopias and utopians embraced the new possibilities that glass offered. Le Corbusier noted that for his age the maxim was transparency not entanglement. Transparency is a property of glass. It makes possible – or necessary – new modes of living, lives flooded by light, or, more dramatically, lives performed in public, no longer behind closed doors and solid walls. Entanglement – for which read intrigue, complexity, secrecy, corruption – would give way in an age of see-through modern social relations to a new honesty, a matter-of-factness with nothing to hide. Utopia is clear as crystal and as beautiful. Glass had earlier been associated with utopia, at just that point when a new building form – the glass-roofed arcade – came into being: London's first, the Burlington Arcade, opened in 1819. Arcades, with their glassed roofs, allowed pedestrians and goods to be washed in light by day and they turned at night into inky canopies of stars.

In the early 1800s the utopian socialist Charles Fourier imagined a self-contained community of 1620 freely associated people, representing a male and a female from each of the 810 personality types he had discerned, living in what he called a phalanstery. The building that was to house his utopian community emulated the arcades' building style. It was closed to the elements and comprised tall windowed street galleries and passageways connecting rooms of various sizes. Fourier hoped to realise his plans in real life, but the only experiment in phalanstery living during his lifetime produced a travesty of his ideas, and Fourierist communities in the New World of America in the 1840s fell victim to state repression, internal schisms over doctrine and financial insecurities. [2]

The imbrication of glass and future hopes persisted. In 1849 Jobard wrote an essay on the architecture of the future for a Paris journal. He observed that glass was destined to play an important role in 'metal-architecture'. Houses, he notes, will be filled with

1 See Marx's 'Preface' to his *A Contribution to the Critique of Political Economy* (1859), available online: http://www.marxists.org/archive/marx/works/1859/critique-pol-economy/preface.htm

2 See the section 'An Architectural Innovation: The Street-Gallery', in *The Utopian Vision of Charles Fourier: Selected Texts on Work, Love, and Passionate Attraction* (London: Jonathan Cape, 1972).

openings, such that they appear 'diaphanous'. Such glassy apertures will transmit (by day with sunlight, and by night with gaslight) 'a magical radiance' inwards and outwards. The emphasis here is on beauty, a new beauty made possible by the technology of glass.

Later, for the Modernists, glass's transparency comes to take on moral and political connotations. Bruno Taut (with his group 'The Glass Chain') designed buildings with translucent surfaces, impelled by a fervent sense of human life lived in unity with nature. This Expressionist vision drew on a cosmic language and saw the window-walls as points of access to the infinite spectacle of nature. From a different angle, Mies van der Rohe and Frank Lloyd Wright rebuffed the dusty clutter of the Victorian epoch. They embraced glass architecture from a functional perspective in the belief that transparent walls allow for transparent relationships. In 1919–21 van der Rohe designed some glass skyscrapers. The sketch for one shows an angular, three-cornered building jutting spikily into the Berlin cityscape. Its glassy walls are luminous against the surrounding dark buildings. Another prototype comprised three connected curved towers and its fully visible suspended floor planes appear like the discs of a spine. The skyscrapers were held up by steel structures that acted as their 'bones'. The glassy panes were their skin. The skyscrapers were designed to reinvent the types of lives and relationship that would take place within them. More than this, they would form a body for their inhabitants, showing thereby that the new world could find ways of meshing humans and their technologies organically. The skyscrapers were never built – at least, not these dreamt by van der Rohe, though others appeared later as baubles of the corporate world, full of confusing, opaque and ultimately protective reflections, or what utopian writer Paul Scheerbart had earlier warned against in the potentially 'dangerous' form of 'Tiffany effects' or silvered mercury glass.

For Scheerbart, theorist of glass architecture and writer of science fiction, glass heralds the possibility of new, revolutionary modes of existence. Scheerbart delighted in the luminosity of glassy utopias. In 1914, in his architectural polemic *Glass Architecture*, Scheerbart wrote of a future glass architecture that would let in the light of the sun, the moon and the stars. He began his polemic with the observation: 'Our culture is to a certain extent a product of our architecture'. Our 'closed rooms' must give way to a 'higher level' of existence in which 'the light of the sun and the moon and the stars does not enter the room through a few windows – but rather all at once through as many walls as possible, made entirely of glass – coloured glass'. This glass architecture would allow the beautiful light of nature to stream in, but more importantly it would change for the better the face of the earth, as seen from space. Scheerbart writes:

> The surface of the earth would change immensely if everywhere brick architecture were replaced by glass architecture.
> It would be as if the earth had clothed itself in jewellery of diamonds and enamel.
> The magnificence cannot be imagined.
> And then we would have all over the earth things much more luscious than the gardens in A Thousand and One Nights.
> We would have a paradise on earth and would no longer need to gaze longingly at the paradise in the heavens.

3 All quotations from Scheerbart are from his *Glasarchitektur* (1914), available online: http://www.scheerbart.de/ps_0013.htm#Glasarchitektur

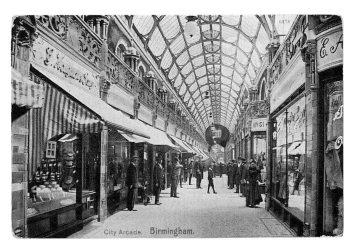

City Arcade, Birmingham

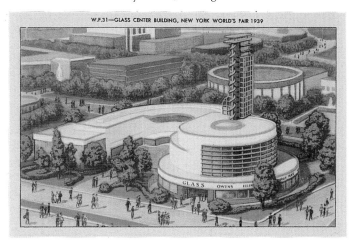

Glass Center Building, New York World's Fair, 1939

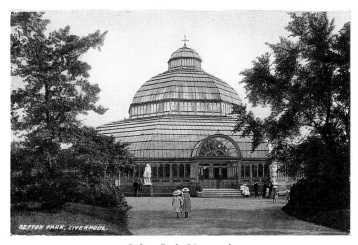

Sefton Park, Liverpool

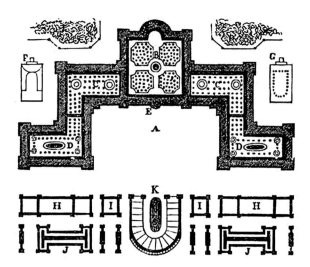

Fourier's Plan for a Phalanstery

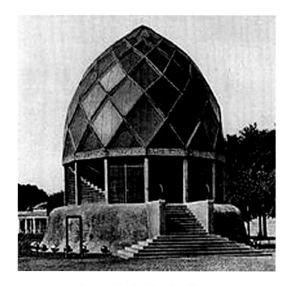

Bruno Taut's Glass Pavilion,
Werkbund Exhibition, Cologne 1914

Electricity would make the transparent buildings – homes, factories, market halls, churches and temples, parliament buildings, hotels, hospitals and sanatoria – twinkle and shimmer in the night. And movable mirrors and spotlights would intensify the light effects of the buildings. Scheerbart advocates glass cars and motorboats and high-speed trains, which will convert into admirers all those sensitive types who despised the first railways of iron. Glass airships will be fitted with coloured headlamps, to facilitate the vehicles' signal language. Scheerbart dreams of illuminated glass columns that make it seem as if architecture is free-floating. These columns of light could act as orientation markers for the airships. Each would be differently formed and lit. Scheerbart's is an aesthetics of appearance, all shimmering surfaces, a play of light and reflection, a fairy-scape. But it does not stop there. It asserts a functionality, identifying glass with flexibility, shape-shifting, mobility and openness. Scheerbart demands endless variation in form – no repetitive lampposts or building forms. Variety is crucial. It will be the motive for travel. Scheerbart assumes that nine tenths of the newspapers' reports will be of new glass effects somewhere in the world. Glass is equivalent to 'the new'.

Scheerbart's pamphlet is a mixture of technical manual, aesthetic theory and moral philosophy of culture. In addition to its aesthetic wonders, glass, Scheerbart argued, incubated a new morality. Glass's purity and crystalline form hide nothing, allowing nature to flow in and the interior's light to shine out. This transparency makes it the contrary of stone and brick. Those two are hard coatings, impenetrable, blocking – like a shell or armour, excluding the world. For Scheerbart glass is like a skin or a membrane. The wall as transparent plane becomes a window, but because it is all window, it is more like an eye. Looked through, it disappears. That which is looked through, the window, becomes the very mechanism of looking, the eye. Human and object are one in this setting. This is a world of ease and facility, as passage between its parts is achieved through doors that open and close automatically. The glass house is a new body for new people who inhabit it and see through it, pass through it with ease and yet are protected in it. This house as body is a familiar theme in utopian architecture. It is as if in the imagining of a perfect future world there should be no difference between the structures we inhabit and ourselves. This is the bringing into alignment of humans and technologies that utopia so often vaunts, and its happy proclamation is that the exploitation of nature, including ourselves as natural beings, is over. In 1914, as an architectural form, it was almost as utopian as Fourier's phalansteries had remained, and it would not have survived the aerial bombs to come in the First World War (despite Scheerbart's fantastical claims that glass architecture was better suited to a militaristic age, for, in war, the frames would buckle and glass panes would shatter, but it could be easily repaired and, unlike brick architecture, it would not tumble, killing passers-by. Glass is permanent. It is, notes Scheerbart, not destroyed by time nor fully obliterated by dynamite or bombers. Scheerbart insisted on glass's fundamental strength, convinced that the chemical industry could develop glass that was tougher than cement. Brick goes rotten and harbours bacteria, which seep into the air of the rooms it surrounds. Glass does not. It remains clean and pure.

The new glass milieus will 'completely transform people', Scheerbart concludes. Scheerbart notes that the 'strange influence' of coloured glass on people's psyches had

already been noticed by the priests of ancient Babylonia and Assyria, who installed hanging baskets of coloured glass, which became stained glass windows in the medieval period. Through light, colour and glass, modern living could be transformed. Glass architecture already existed in the shape of 'glass palaces' in botanical gardens. These had overcome the dull verticality of walls in brick architecture. Glass held together by iron could be adopted in any form and it made possible movable walls. The palm houses, however, lacked colour, and colour was important in order to 'dampen' the starkness of glass's light, which contributed to the 'nerviness' of the age. Technological development has almost made possible a new mode of living, a new beauty and a certain reframing of the natural world. This is a utopia indeed, but one that might teeter on the brink of realisation. Scheerbart's small book is dedicated to Bruno Taut, who in the year of its publication had designed the brightly coloured Glass Pavilion at the Werkbund Exhibition in Cologne, with a fourteen-sided prismatic dome and glass block staircase (which was in turn dedicated to Scheerbart and decorated with his slogans). But such utopian schemes rarely translated into reality. There were to be no glassy worlds that exposed the self to cosmic experience and conceived buildings as aesthetic wonders that enabled new lives. Instead of crystal palaces dotting the cityscapes, great factories of brick had been built and continued to be built.

The characteristics of glass are to be found also in Scheerbart's literary writings. He regarded his utopian science fiction as kaleidoscopic and open. He compared it to an opal, with fugitive facets of colour coming to the fore. In *Münchhausen und Clarissa*, from 1906, Scheerbart notes that in the nineteenth century numerous things were turned inside out, but people were not turned inside out with their things and so they no longer fitted in the world. Baron Münchhausen, the infamous fantasist, sets about re-fitting humans into their world. The Baron travels to a world exposition in Melbourne and relays his adventures in a series of tall tales. He travels to the centre of the earth to witness gemstones, caves, rocks and colours. In a restaurant at the earth's core glass walls divide diners from whale-like animals and jellyfish. Above ground, the exhibition buildings are extraordinary: tall towers are connected by bridges across which rooms travel like lifts or cars, while the towers turn. The architecture is mobile. Visitors can view a changing panorama of nature from one travelling room. Under starlight, the rotating glassy buildings twinkle, beaming their own electric lumination into the darkness that is criss-crossed by coloured floodlights.

Walter Benjamin observed in some notes on *Münchhausen und Clarissa* from the early 1920s that it represents a 'utopia of the body'. The body changes – and this in itself is utopian, for in utopia it is not only the technical arrangements that change. The body inhabits its architecture like a skin. The one moves with the other. The physical nature of humans alters in accord with human technologies. Scheerbart's Münchhausen causes Benjamin to remark that 'the earth forms a body in conjunction with humanity'. The earth and humans live on in tune through the benevolent mediation of technologies.

'To live in a glass house is a revolutionary virtue par excellence. It is also an intoxication, a moral exhibitionism, that we badly need', writes Benjamin in 1929, and he follows this

4 Paul Scheerbart, *Münchhausen und Clarissa* (Hamburg: Rowohlt, 1991), pp. 72–73. See Walter Benjamin, G.S.VI, pp.147–8.

in 1933 with an outline of the properties of glass which make it such a revolutionary material. Glass is

> a hard smooth material to which nothing can be fixed. A cold and sober material into the bargain. Objects made of glass have no 'aura'. Glass is in general the enemy of secrets. It is also the enemy of possession. [5]

Paul Scheerbart causes Benjamin to consider the possibilities of the new 'traceless' 'glass culture'. Benjamin endows glass with political significance. It is sober – here Benjamin echoes the language of Neue Sachlichkeit, the new sobriety. This is matter as fact. Glass is smooth – eschewing historical traces, or at least the negative baggage of the past. Glass makes public. It counters secrecy – and this is what Benjamin took Le Corbusier to mean with his idea of transparency as the watchword. Glass denies private property, and the necessary mistiness and concealment over origins and social relations that private possession implies.

At the close of an essay on his literary hero Scheerbart Benjamin observes that, by his time of writing (the late 1930s), Scheerbart's treasured glass architecture was labelled subversive and undesirable by the Nazi leaders of a Germany now the home of pure reaction. In the same essay, Benjamin notes how Scheerbart's great discovery was that [6] the stars might save the universe and our earth with it. The cosmos is vast and we are a small part of it. Scheerbart died in October 1915, just over a year after the outbreak of world war. His extraterrestrial utopianism pushed him to reject the common name for the war and to place his hope elsewhere, notes Benjamin, citing from memory Scheerbart's cosmically optimistic lines:

> Let me protest first against the expression 'world war'. I am sure that no heavenly body, however near, will involve itself in the affair in which we are embroiled. Everything leads me to believe that deep peace still reigns in interstellar space. [7]

Utopia still exists in the world, in that non-place beyond our grasp. For Scheerbart its contours were glassy. Glass seems to represent facets of a hope, for us, on earth.

5 Walter Benjamin, 'Experience and Poverty', in *Selected Writings*, Vol. 2 (Cambridge, MA: Harvard University Press, 2001), pp. 733-34.

6 See Walter Benjamin, 'Sur Scheerbart' (late 1930s) Gesammelte Schriften vol. II.pt. 2, Frankfurt: Suhrkamp 1991 p.6632. In English in Walter Benjamin, *Selected Writings*, Vol. 4, 1938-1940 (Cambridge, MA: Harvard University Press, 2003).

7 Cited in Benjamin, 'Sur Scheerbart', p. 630; English edition, p. 386.

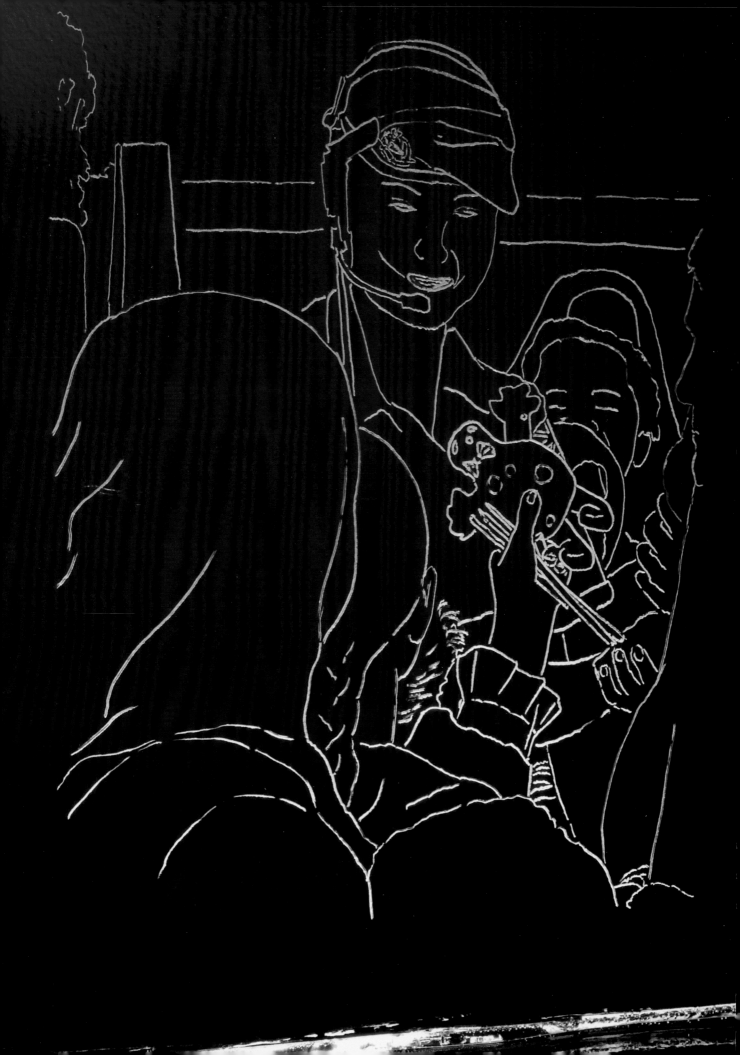

» This is Propaganda «*

The woman with the headscarf smiles shyly. The baby in her arms happily clutches the outstretched finger of the British soldier. It laughs over the full breadth of its small face and gazes gratefully into the eyes of this newcomer. The soldier bends down to the small child. He is also smiling. He looks determined to get the child's sympathy. The caption reads:

> One of the babies enjoys a little fussing from a Fusilier. Families of the Regiment at home in the UK and Germany donated toys for the clinic's waiting area. The health centre cares for a district of 30,000.
> (Click here for high resolution version) [1]

What at first looks like a snapshot – in front of an Iraqi hospital, a child is happy about the present from the hands of a soldier – is revealed on second glance as extremely manipulated, as staged photography. Not only the soldier, whose headwear designates him as a member of the 1st Battalion of the Royal Regiment of Fusiliers, but also the camera draws in very close to the Iraqis – nearer than any foreign observer would be allowed. With the soldier, the photographer also bends down to the eye level of the child. The small group is arranged in such a way that it opens up to the camera. Thus, the friendly encounter between Iraqi civilians and the British soldier becomes our own. In the close-up perspective, the picture no longer allows a distanced view. The photo draws us into the intimate sphere of the encounter. It doesn't merely allow us to take part in the emotions and sympathies on display. Through its visual strategies, it forces us to participate.

In pictures like these, the British Ministry of Defence sees the deployment of their soldiers in Iraq within the framework of 'Operation Telic'. The photos are on the MOD website ready to be downloaded, and are meant to inform an interested public about the operation in Iraq. The different motifs have one thing in common: although British [2] and Iraqis meet as unequal partners, they are full of respect and mutual trust. According to these pictures, military measures are being implemented largely without resistance. Unlike the drama of 'embedded journalism' dominating the reporting of the Iraq War in the media, these are pictures that would hardly find their way into the press. The visual documents collected here don't focus on fighting or on the heroism of the soldiers, but on the constructive efforts of the military, the delivery of aid to the populace, and contact with civilians.

In another picture, a small boy stands barefoot in the sandy street in front of a rough façade. Like his younger brother, he is only dressed in a modest *thobe*. He has bravely stepped forward – away from his brother and his mother sitting against the façade –

* Refrain from the eponymous song by the group Briskeby, from 2000, quoted from Tino Sehgal, *This is Propaganda*, 2000, Inv. T12057, London, Tate Modern.

1 http://www.operations.mod.uk/telic/images/humaid/basrah_clinic3_hr.jpg, last accessed 3 December 2006.

2 http://www.operations.mod.uk/telic/photo_gallery.htm, last accessed 3 December 2006.

17

THIS IS PROPAGANDA 17

towards the soldier, who has crouched down in full combat gear to show the boy his rifle. Two worlds meet. In his camouflaged combat gear with a helmet and heavy weapon, the soldier looks as though he has come from another planet. Nevertheless, the boy trustingly comes forward, and curiously bends down. He supports his hands on his knees, the better to look into the weapon. Smiling joyfully, he looks through the weapon's sight.

> A soldier from the 3 Para allows a fascinated Iraqi child to look through his rifle's optical sight.
> (Click here for high resolution version)

However, the boy's voluntary look is much more than a harmless children's game. The highly symbolic encounter of the soldier with the child conceals a complex game with exchanged and inverted standpoints. Just as the British soldier has bent down to the boy's height to present him with the rifle, the photographer has also crouched down for the scene, and allows us a participatory view at the level of the small Iraqi. From the low angle of the boy, we look at his own 'fascinated looking'. *What* he sees remains uncertain. Certain, however, is *how* he sees his environment. While the gaze of the viewer is shifted to the eye level of the child, the child takes on the perspective of the occupier. Through the sight device of the rifle, his gaze onto the familiar environment resembles the coordination of a potential military target. In the weapon, looking and focusing become one.

We come across the happy, smiling baby and the small boy looking through the optical sight once again in Nick Crowe's installation *Operation Telic* (2005). In this series, Crowe radicalises the question of the visibility of the war in Iraq. He takes the public internet pictures of the MOD as a starting point for his own work. Through a conscious reduction of the originals, he achieves an abstraction and sharpening of their motifs, while heightening the intended message. From the high-definition colour image available for downloading from the internet, only the bare contours remain, emptied of all those elements in the photographs that suggest an everyday quality and a direct connection to reality. It is a matter of paring the image down, a concentration on the essential. In our case, a small boy happily looks through the sight of a soldier's weapon. Everything that might characterise the environment or individualise the scene disappears in the summary outline. Only the contrast between the unequal pair is heightened. Their unexpected rapprochement becomes an allegory of 'asymmetric' encounter between small and large, between Iraqi civilians and British soldiers. In the reduction to the basic figures, Crowe sharpens the gaze on the actual polarity that underlies the pairing. It becomes immediately clear that such motifs – the soldier as friend of the sick baby, and the soldier who offers his weapon to the young Iraqi instead of aiming it at him – haven't been produced and selected for the website randomly.

The contrast between civilians and uniformed soldiers is a familiar part of the visual history of war. Such motifs, however, usually mark the unequal parties to establish differences between the opponents in a partisan way. The picture on the MOD website seems to be intended as a deliberate counterpoint to motifs attempting to make moral

3 http://www.operations.mod.uk/telic/images/ops/3para_children_hr.jpg, last accessed 3 December 2006.

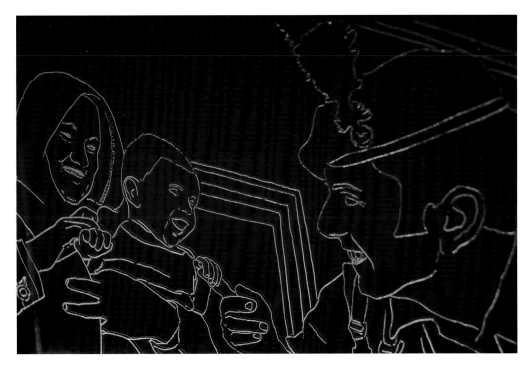

Operation Telic: Soldiers Talking to Women (detail)

Operation Telic: Thumbs Up (detail)

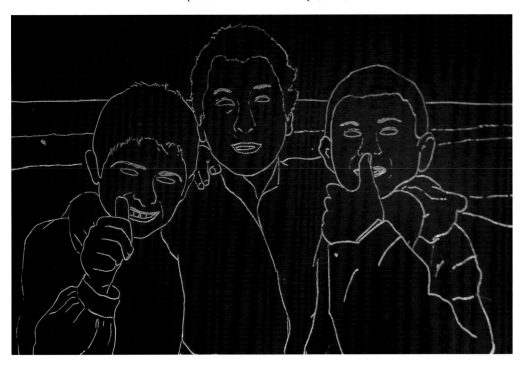

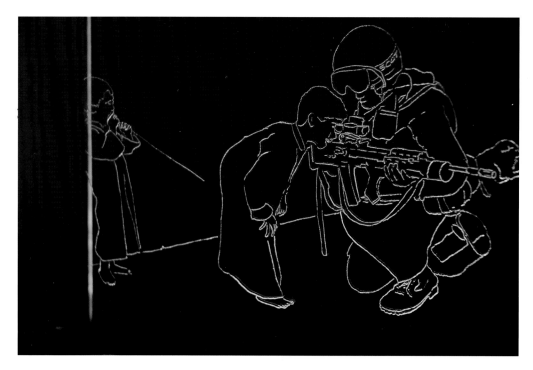

Operation Telic: Kids Looking Through Sights (detail)

Arabic news agency Al Jazeera website, screenshot from 14 April 2004

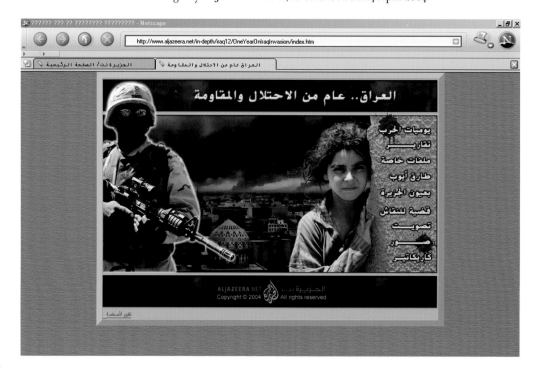

capital out of the contrast between soldier and civilian. For example, with the title image of an internet feature to mark the first anniversary of the American invasion of Iraq, the Arabic news agency Al Jazeera shows a particularly pointed heightening of the conflict. Against the smoking backdrop of Baghdad, an American soldier threatens an Iraqi girl with a raised rifle. The black, uniformed soldier, whose individual features are concealed behind mirrored sunglasses, approaches the defenceless child out of the background. The girl nervously searches for protection against a projection of wall, and imploringly turns her gaze to the viewer. As if the brutality of the invading army hadn't been properly established by this artfully produced contrast, two bloodstains extending beyond the frame of the image have been added to the wall in Photoshop.

We can guess at the degree of objectivity to be found in the subsequent reportage on the site. Along the axes weapons/combat status/age/sex/skin colour, the graphics set up a deliberately asymmetric personification of the conflict. The picture thereby creates a moralising context for the events and facts presented. With the title image in mind, a neutral evaluation is scarcely possible. Even the navigation menu is found at the side of the small girl – in the target range of the weapon and in the place of 'spilt' blood.

Equally, however, the staged images displayed by the MOD are far from neutral; rather they are carefully orchestrated to depict the British military presence in Iraq in a positive way. For the series *Operation Telic*, Crowe has engraved motifs from the MOD website onto sheets of glass. Grouped according to theme – medical aid, soldiers meet women, soldiers in groups of children, kids looking through guns – the glass sheets are mounted on shelves and lit from below. In this way, Crowe's work produces 'after-images' of the internet photos. The self-staging of the British military becomes a light-dance, whose strange glow forces us to think about how such images are perceived.

Thus, in the picture with the young boy looking through the rifle, the sand tones of the photograph have given way to a poisonous green glow. The impression grows that we are looking at the scene through the night-viewing device of a weapon whose lens would result in a similar reduction of colour. Unavoidably, we are reminded of images of night bombardments or frontline reportage, merely as a result of the colour of the scene. Such pictures can also be found on the MOD website, where combatants can only be made out against the darkness of the night-time scene by their green outlines:

> The officer commanding D company, Black Watch, checks his map during a major search operation on the west bank of the Euphrates in the early hours of 1 December.
> (Click here for high resolution version)

Crowe produces images that analyse other images. The transferral of war images to the medium of the artwork is an expression of a deeply felt mistrust about the official use of such images. His own images are an active reflection on the role and function of these representations. He gives the visual back its physical presence. By being reworked manually, the digital images become tangible objects. The artefacts give the familiar images a new aspect. They attempt to expose the banal – though never innocent – rhetoric

4 http://www.aljazeera.net/in-depth/iraq12/OneYearOnIraqInvasion/index.htm; screenshot from 14 April 2004
5 http://www.operations.mod.uk/telic/images/bwbg/bw_night_search.jpg, last accessed 3 December 2006.

of the original motifs. Crowe's work in glass is, in the truest sense of the word, incisive. There is a real violation of the glass surface through the perforation with the diamond-pointed cutter. The contours of the motifs are engraved into the rough – also hand-cut – glass plates, whose rough edges sparkle hypnotically and threateningly in the darkened room. In the transparent sheets, the contours are given a haptic quality, though at first they are only visible as a light effect. In the material of the glass, the 'images' persist all the more insistently in an imaginary sphere. And even the shade of the glow has something unsettling: the green of the light comes from the iron content of the glass. Not by chance is the origin of this green glow, which makes the motif visible, the result of a poisonous substance.

Crowe's montage of the filigree but sharp-edged sheets of glass on the wall supports brings the motifs of war to a local setting. The installation transfers the digital image from virtual space to our real environment. It becomes part of our private memory-culture, and is thus to a certain extent familiarised. Crowe's work can be seen in a tradition of critical encounter with the visual propaganda of war as it was decisively formed in the photo series *bringing the war home, house beautiful* (1967–72) by Martha Rosler. The collages of the American photographer and theorist combine political engagement with a reflection on the status of images. Beyond the curtain that the housewife has drawn in order to clean the window, instead of the expected garden, we see a scene from the Vietnam War. The window becomes a screen on which pictures of the distant war come into contact with the domestic. In an update of this series for the Gulf War, *bringing the war home, new series* (2004), soldiers suddenly appear in the domestic environment between a seating corner and a coffee table. The distinction between fighting zone and domestic setting is shattered. The observer looks on helplessly at the now unfamiliar and threatening environment.

Instead of 'shocking' war images, Crowe shows the banal and constructed images from the internet in order to determine in what form the occupation of Iraq is perceived in the domestic living space. By transferring the images onto a display shelf, the true intention become more recognisable – it 'brings home' what is intended for the home, and at the same time raises the question of the actual 'place' of these pictures.

The picture archive stored on the internet produces a kind of collective memory. However, internet pictures are fleeting images – they have an indefinite existence and durability. They are as quickly downloaded as moved, exchanged, altered or even erased. Their appearance on the screen is determined by a mouse-click. The decision to see a thumbnail image in high resolution, for how long or how often, is made by the user alone. Access from the personal computer really does have something personal. By being downloaded, the photos enter our private sphere, appear on our screen. We take part; army manoeuvres become part of 'our' memory.

Crowe's work attempts to re-stage this private appropriation of public images. His installation transfers the ephemeral digital image into traditional forms of private memory. Put in rows like holiday pictures and family photos on a living room shelf, the scenes of friendly encounter between the soldiers and Iraqi civilians become part of our own history.

Crowe's installation, however, quickly freezes the smiles of the protagonists. In his work, happy faces suddenly congeal into grimaces. The shelf over which they glow is

thickly daubed with fluid black plastic. This glutinous mass runs to the edges of the support and threatens to drop off in thick drips. Below the support, a dangerously constructed light source can be made out. Numerous wires are roughly connected to light strips. One tries not to get too close for fear of an electric shock. There seems to be a real danger of the jumbled connections short-circuiting.

While the MOD images present the occupation as an aid effort, and the war activities as a friendly encounter, Crowe's staging shifts the smooth visual world of mutual understanding back to the risky undertaking of a war for petrochemical resources. Where the visibility of the MOD pictures suggests security and sovereignty, Crowe emphasises danger and risk. It is not coincidence that the picture supports, with their carelessly cabled light strips, recall the homemade bombs of terrorists. The installation brings the pictures symbolically 'back home', and at the same time leaves them exactly where they originated: in the middle of the battle zone.

Today, wars are increasingly carried out with the help of banal pixels. In the conflict between unequal enemies, wars can no longer be won using conventional weapons alone. Whether it's a matter of groups of kidnappers who execute their victims in front of a running camera merely for the images that are subsequently spread throughout the internet, or suicide bombers, whose acts of violence aim exclusively at the creation of an effective image, the so-called 'new wars' raise the question of visibility in a fundamentally new way. The visible presence of violence increasingly becomes a weapon itself – worldwide and in real time. Psychological warfare consciously transgresses moral limits to meet the adversary in an unexpected form and at his most vulnerable point. However, the active use of visual communication as an integral part of warfare is not an invention of terrorists – but terrorists have taken it to extreme lengths as the so-called "propaganda of the deed". Crowe's work makes clear that media images may be banal, but they are never non-partisan.

Wars as such are invisible. Not even the warring parties are completely aware of the consequences in their complex, destructive reality. For the public, far away from the battlefield, this is even more the case. We only see what is given to us in the image, and which we have the technological means to access. To a certain extent, we are in a similar situation to the small boy looking through the rifle of the British soldier. With our curious gaze, we are all too quickly victims of the military logic of what we are given to see. Before we have really understood what we are seeing, we already find ourselves in the middle of the fighting zone. The picture that we are looking at has long since become the weapon.

Operation Telic, 2005–2006
Installation, Cornerhouse

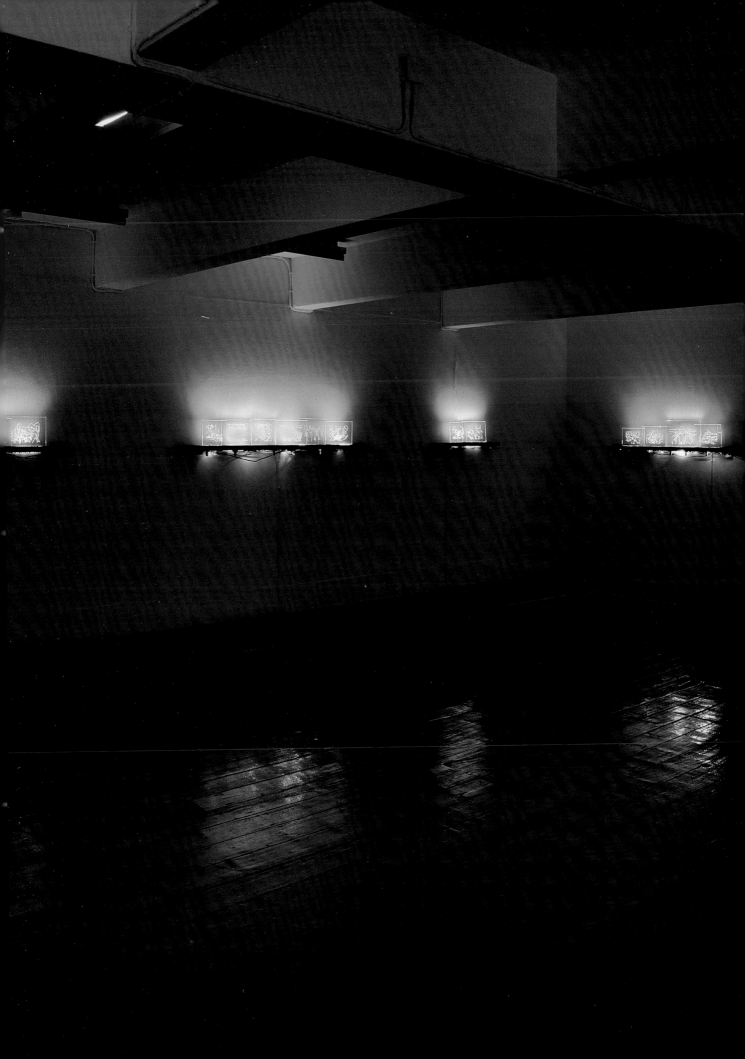

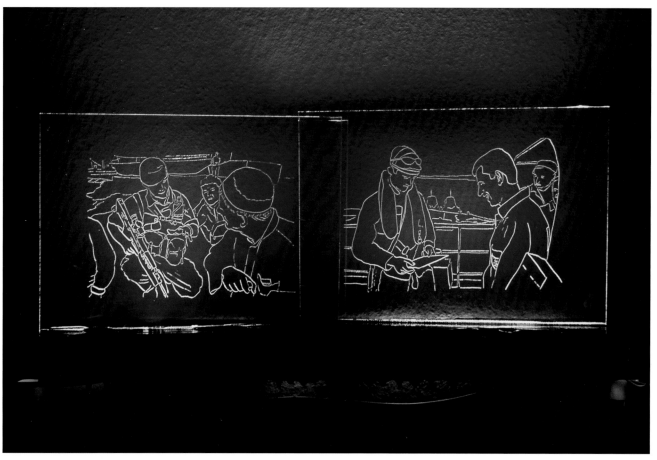

Operation Telic, Soldiers Talking to Men
Visiting Schools and Hospitals

Groups From Above (detail) ›

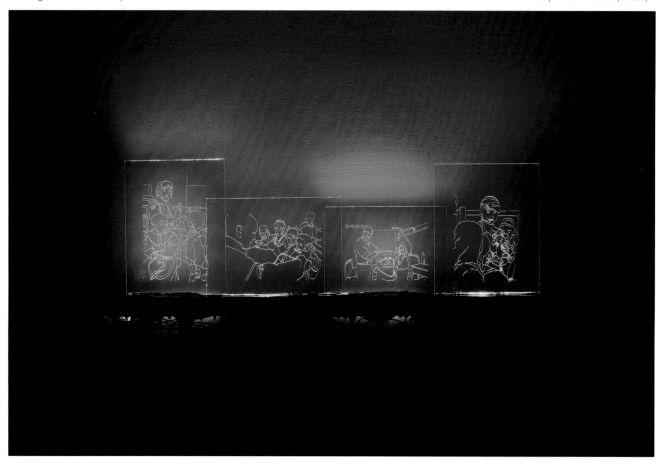

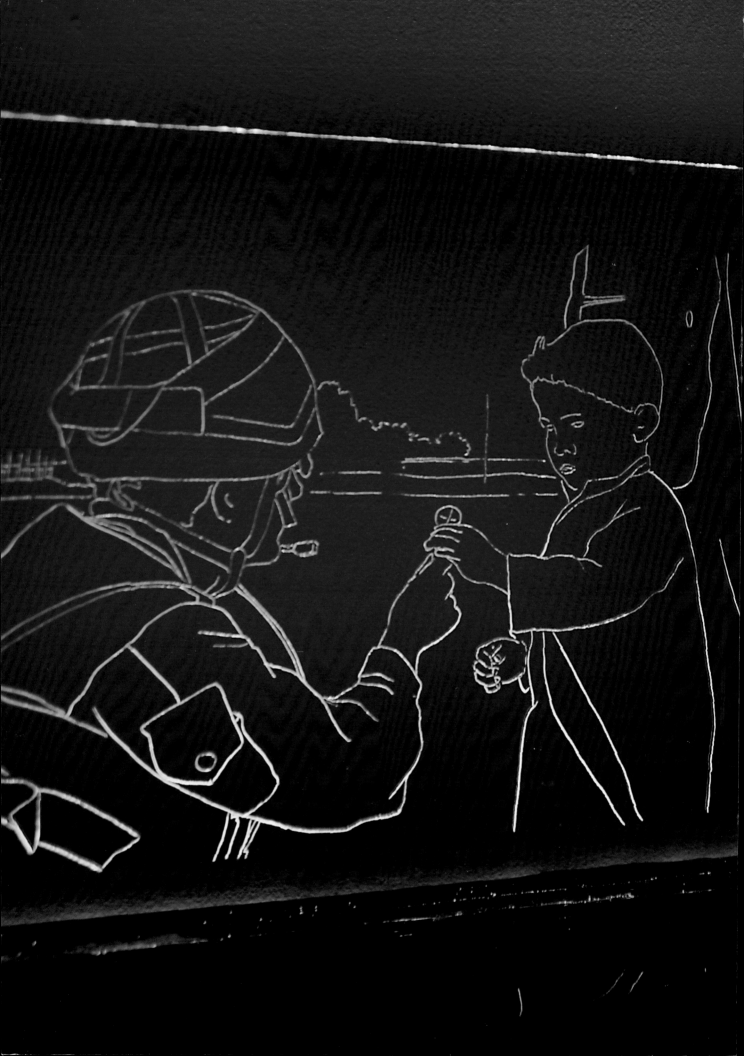

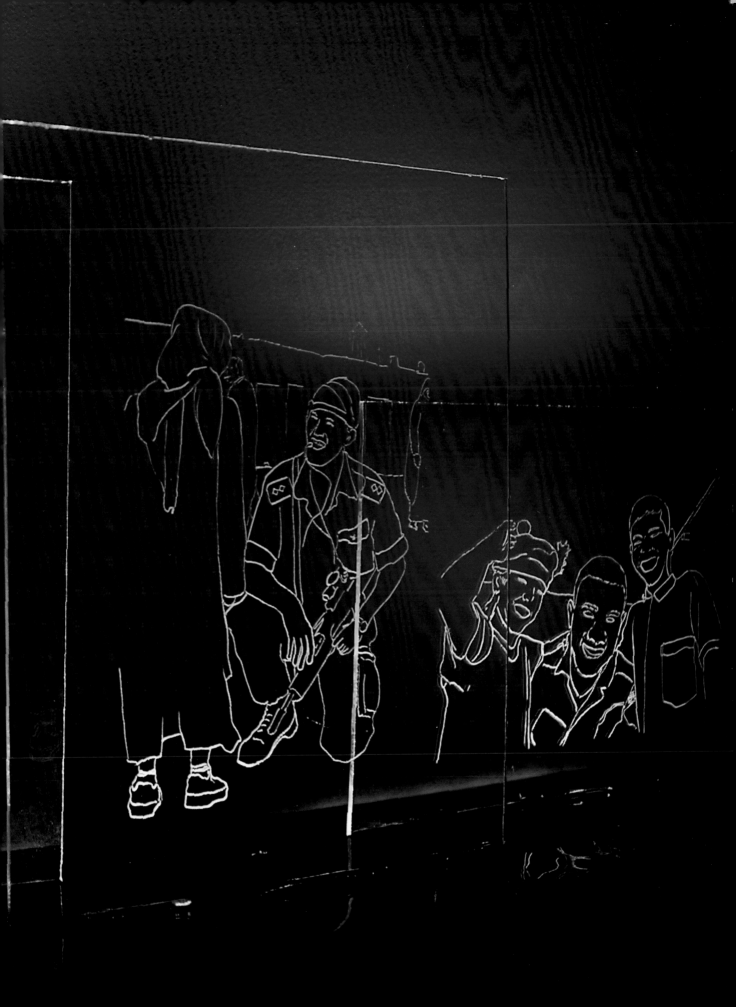

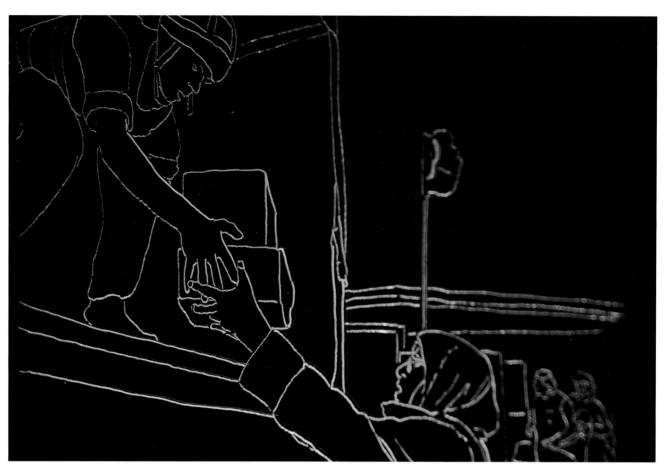

Operation Telic, Distributing Aid (detail)
Soldiers Talking to Women (detail)

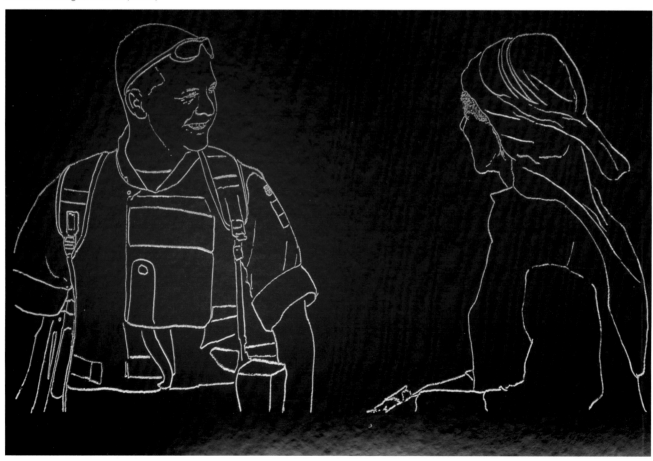

PREVIOUS SPREAD Soldiers with Children (detail)

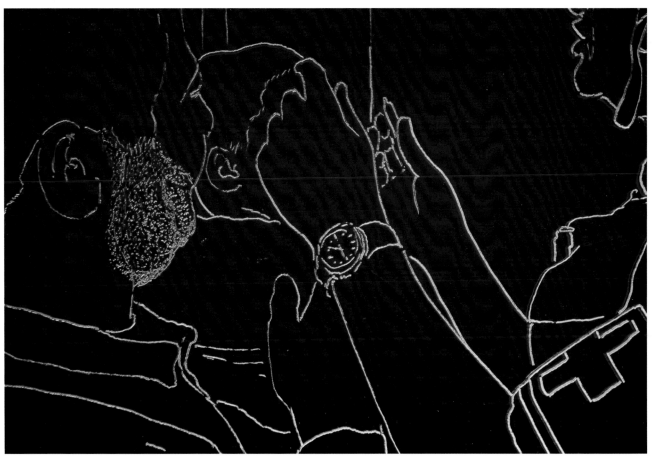

Medical Aid (detail)

Soldiers Doing Civil Order (detail)

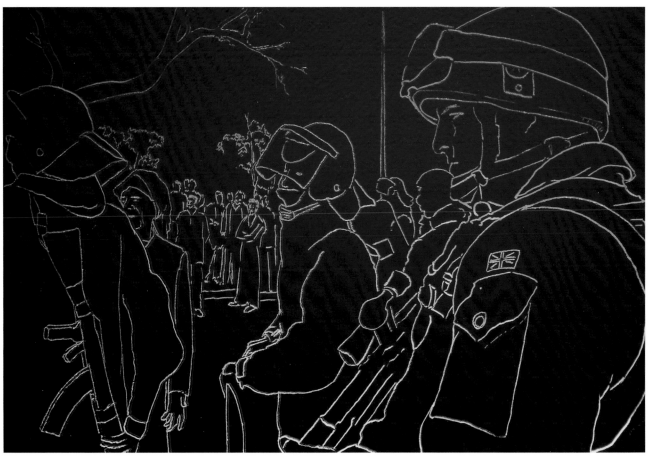

FOLLOWING SPREAD Soldiers Doing War (detail)

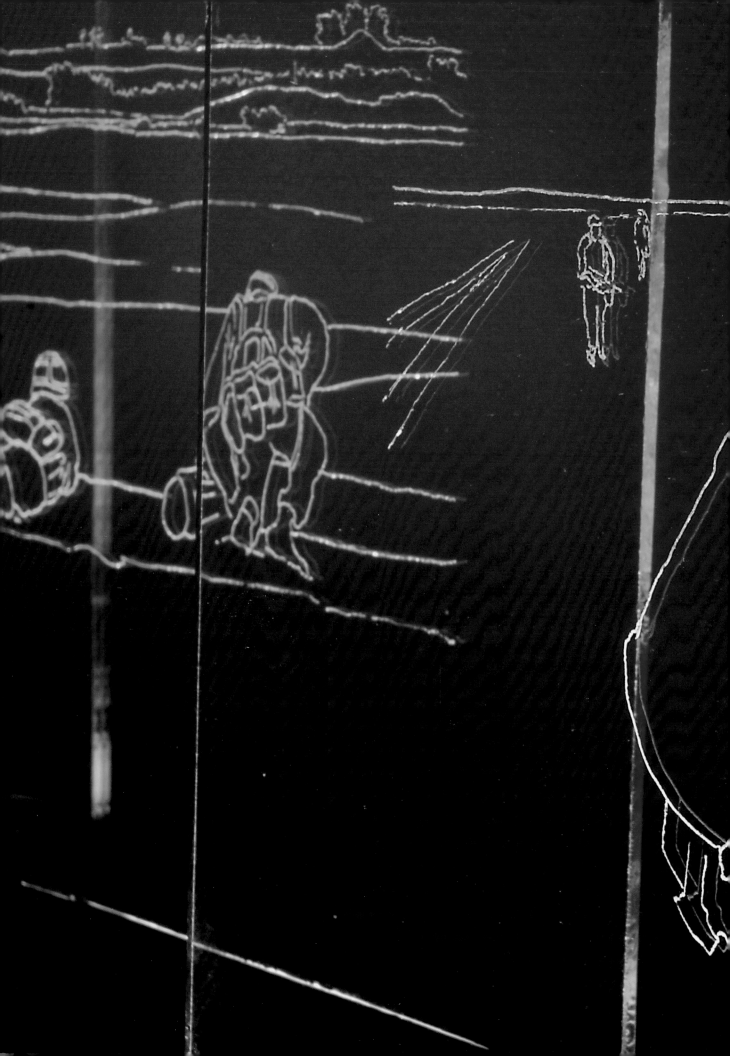

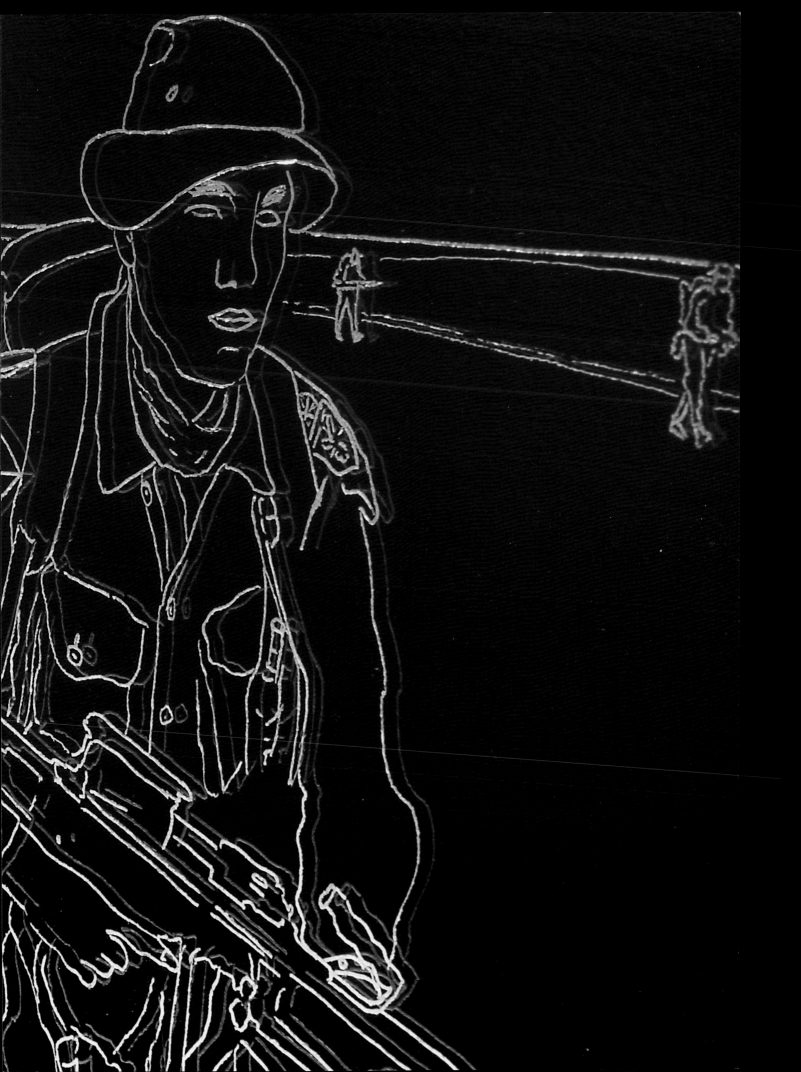

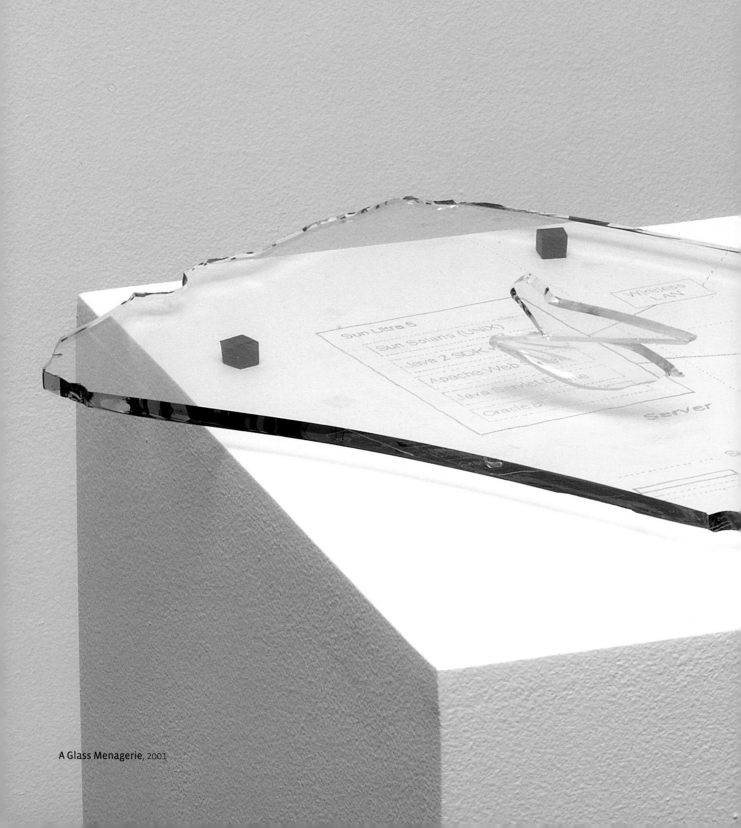

A Glass Menagerie, 2001

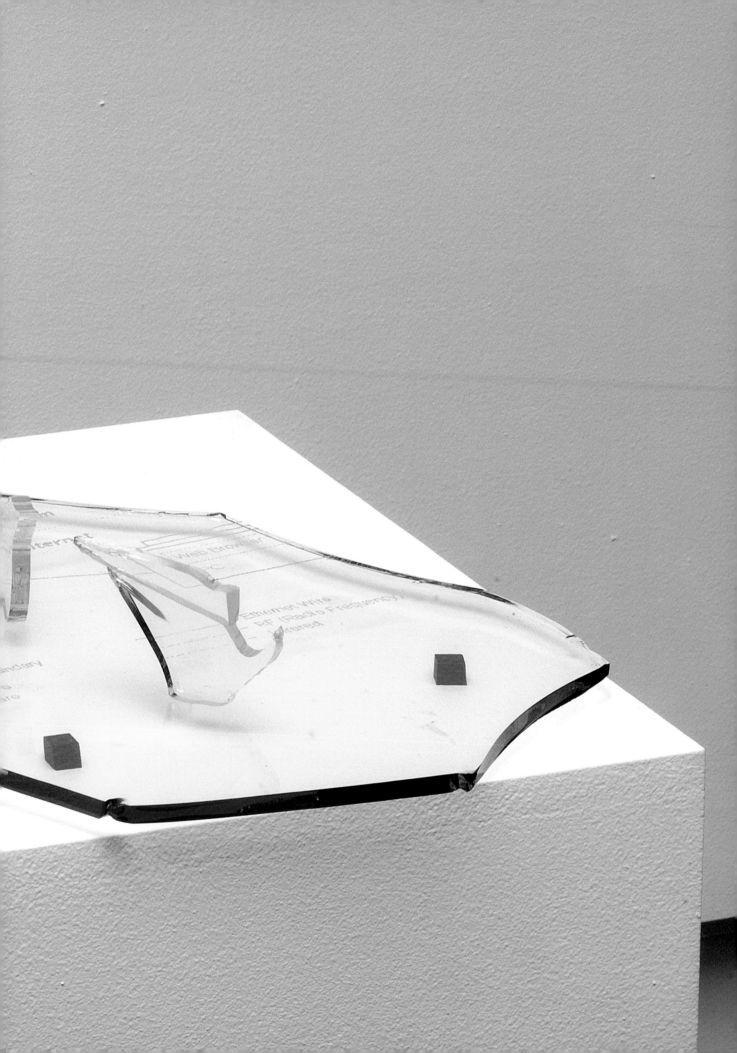

Back	Forward	Home	

Location: http://www.electronicm

Julie Becher, my
Don't know whe

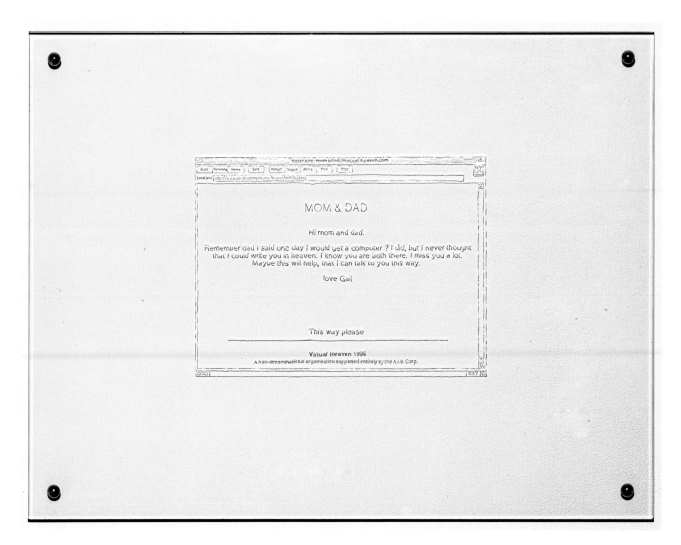

The New Medium, 1999 (detail)

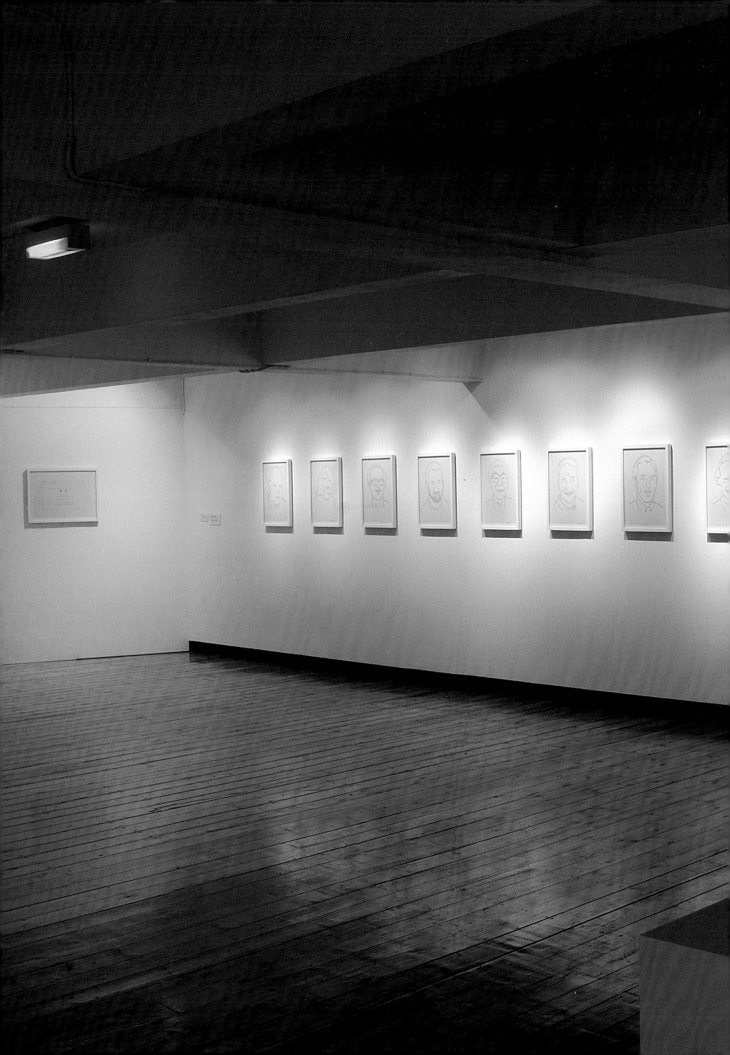

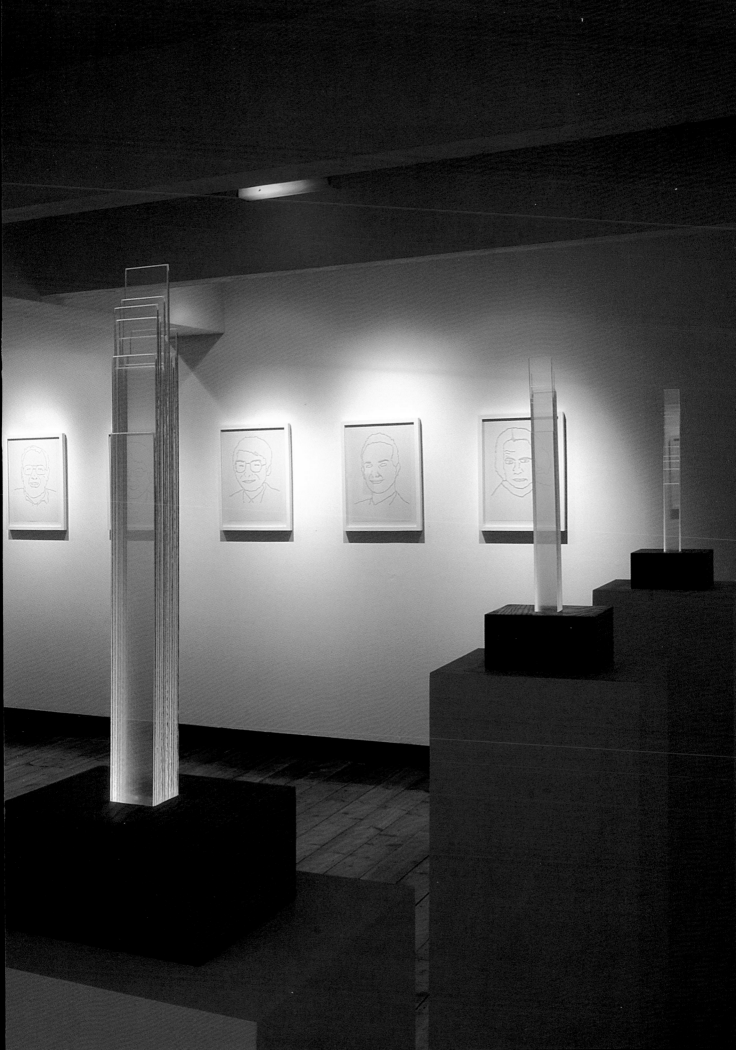

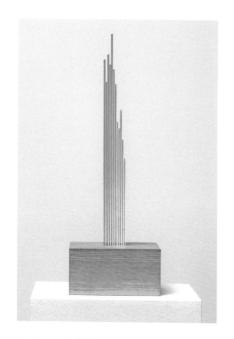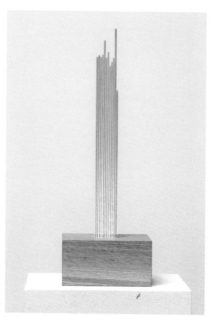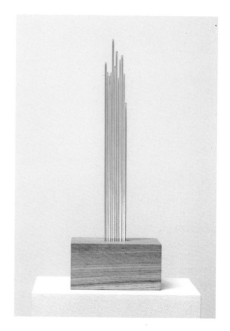

Three Cynical Objects – Nasdaq, FTSE, Dow, 2001
› detail

PREVIOUS SPREAD

Installation , Cornerhouse: **Three Cynical Objects – Nasdaq, FTSE, Dow** and
The Management Committee of the World Wide Web Consortium (W3C)

42

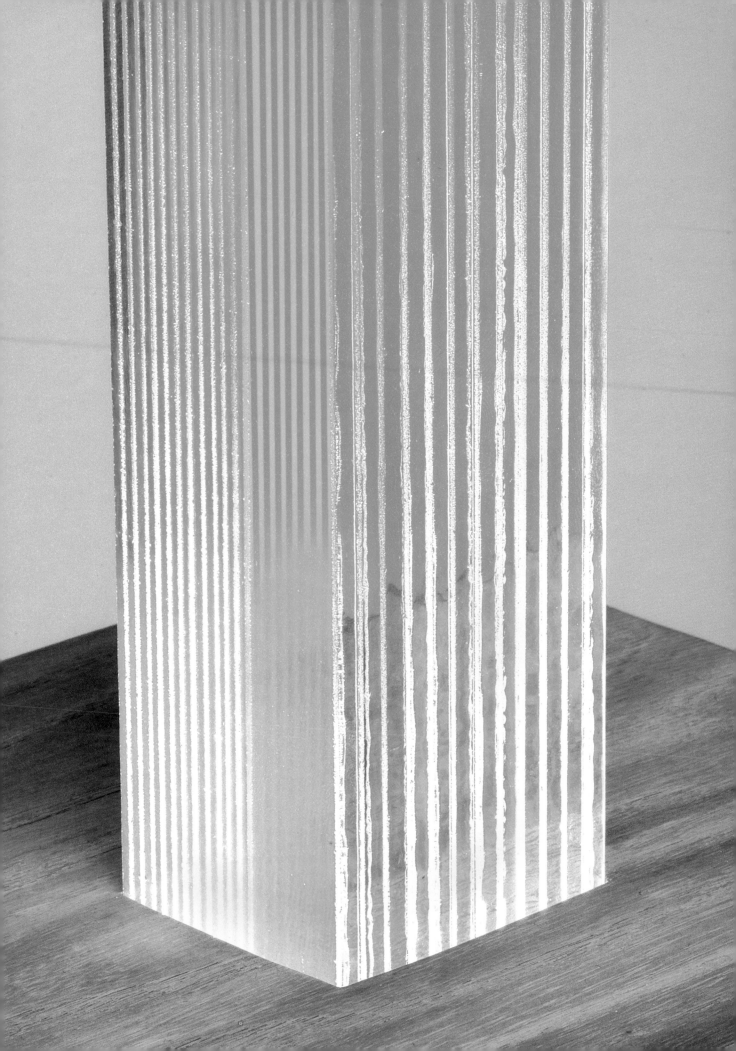

The Management Committee of the World Wide Web Consortium (W3C), 2000
> Vincent Quintt (detail)

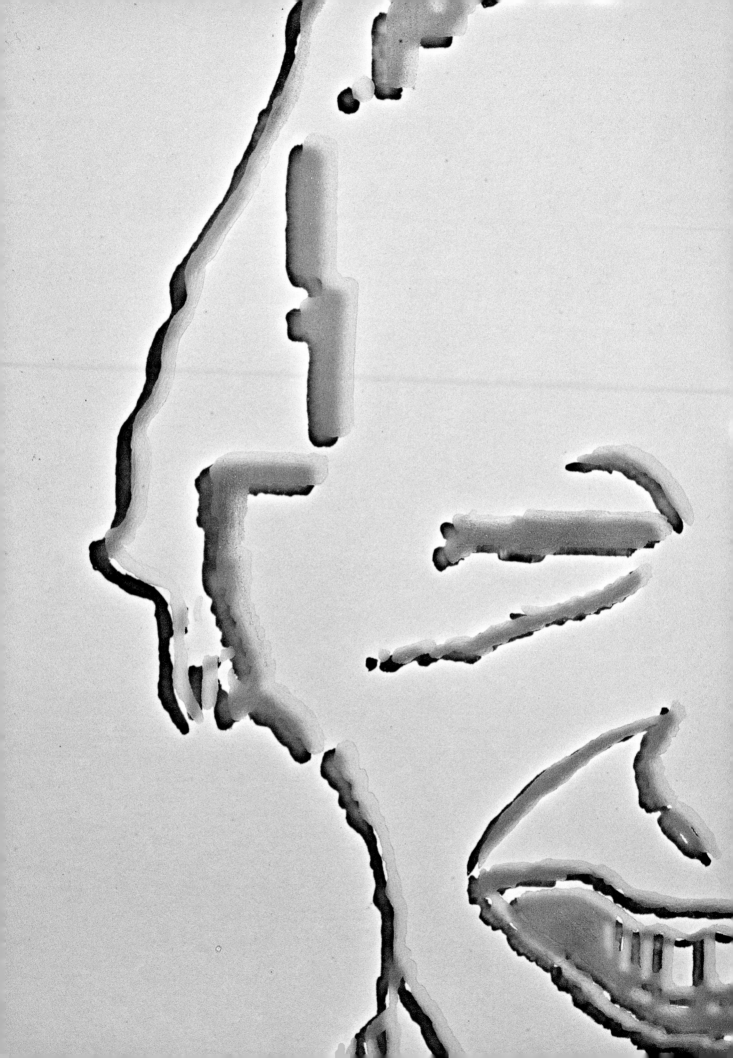

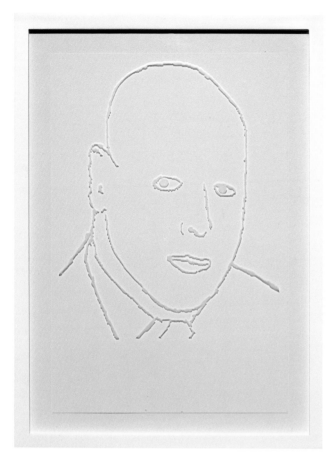

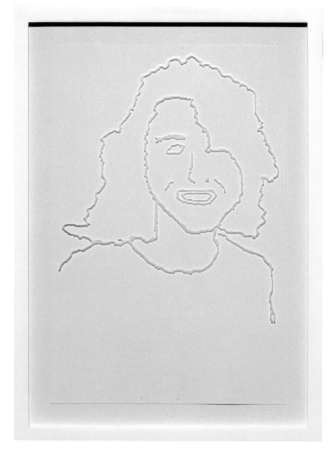

Daniel Weitzner

Janet Daly

Jean-François Abramatic

Daniel Dardailler

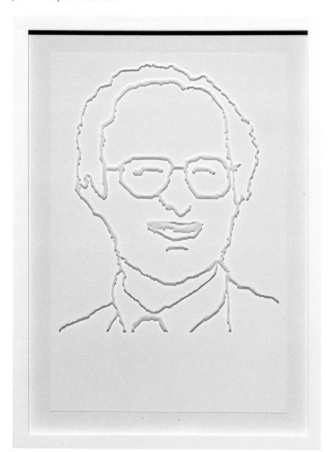

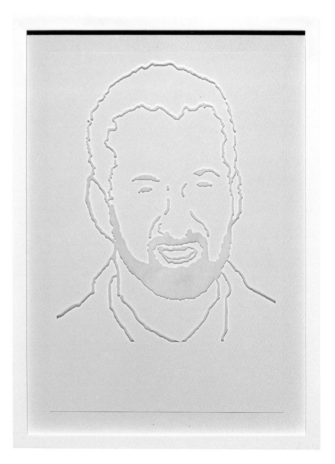

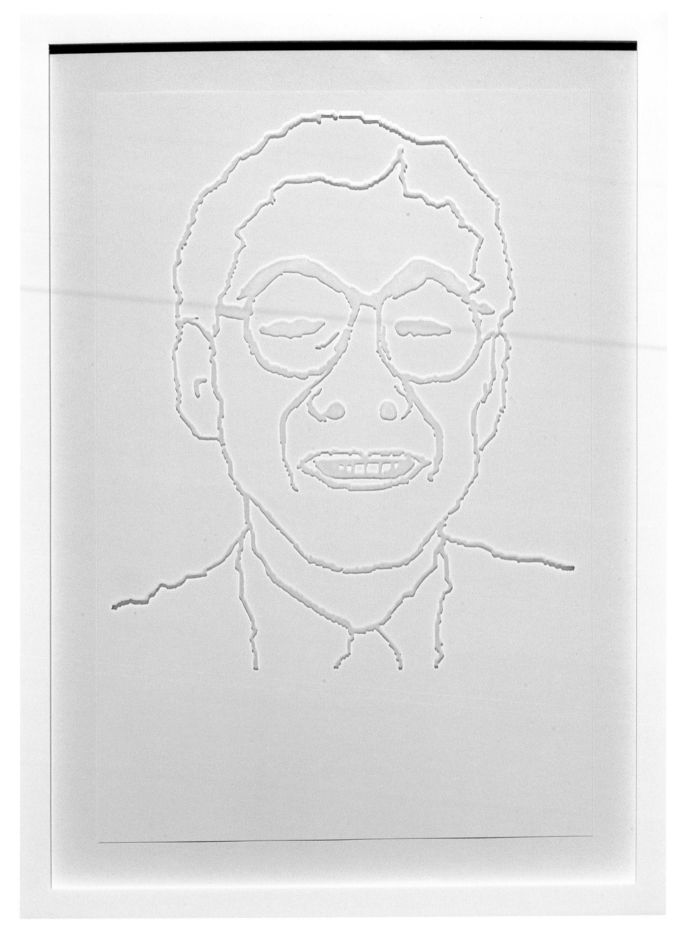

Nobuo Saito

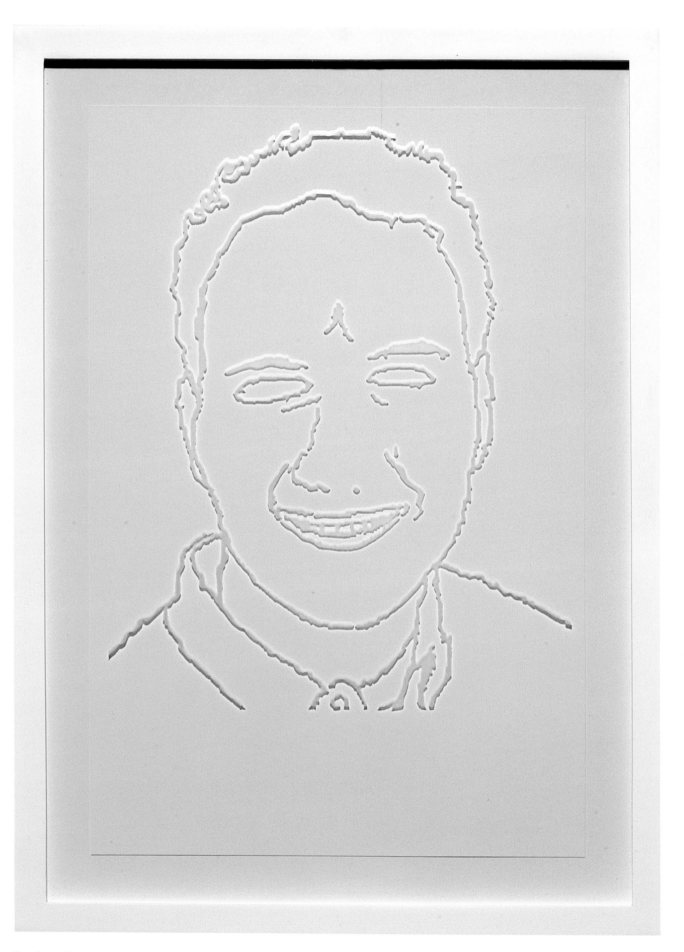

Dan Connolly

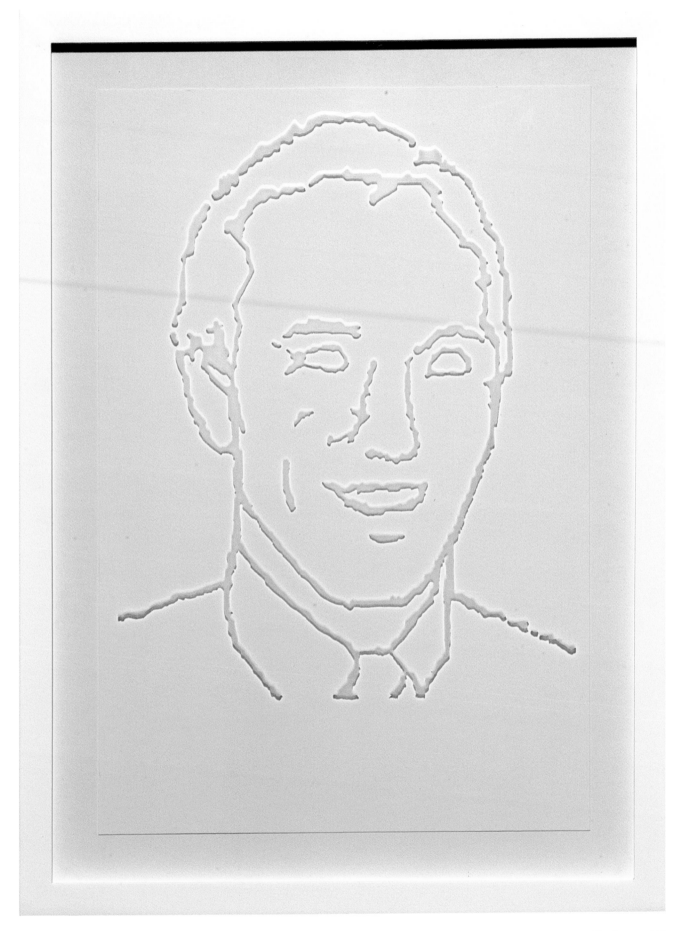

Tim Berners-Lee

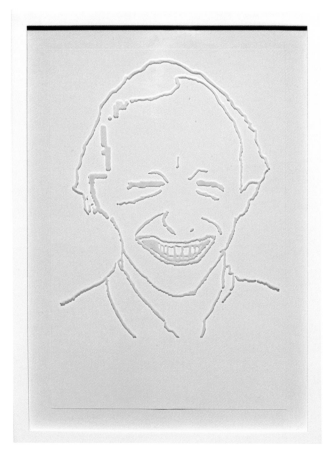

Vincent Quintt

Judy Brewer

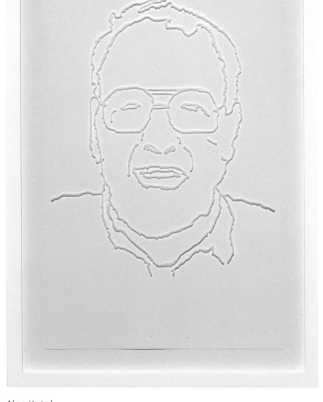

Alan Kotok

Tatsuya Hagino

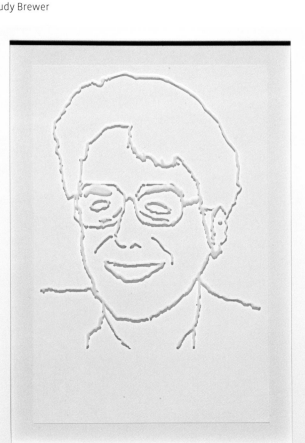

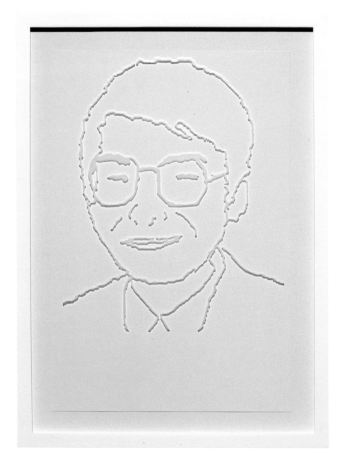

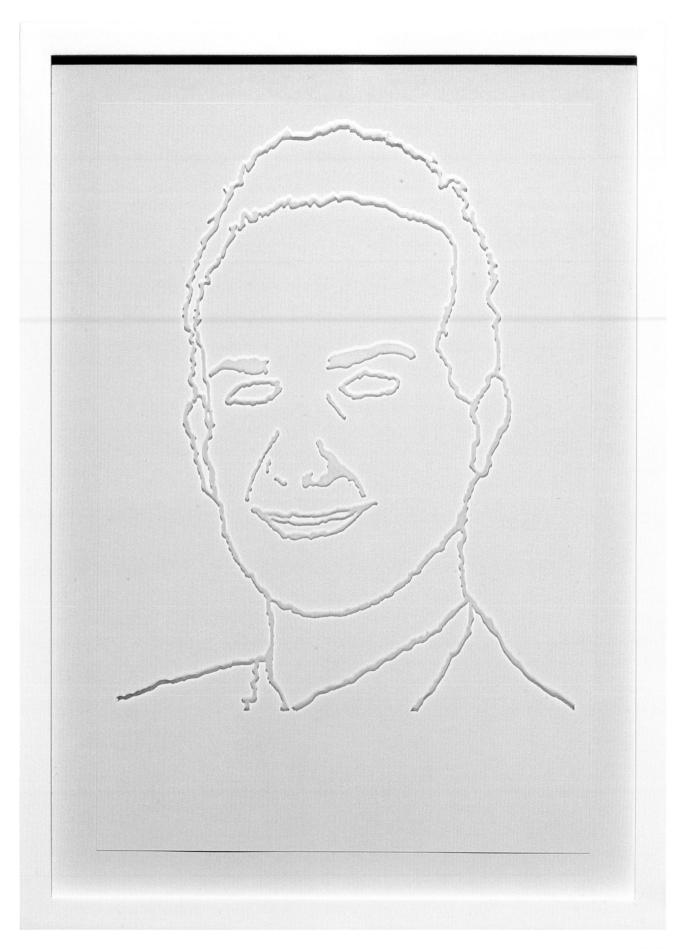

Josef Deitl

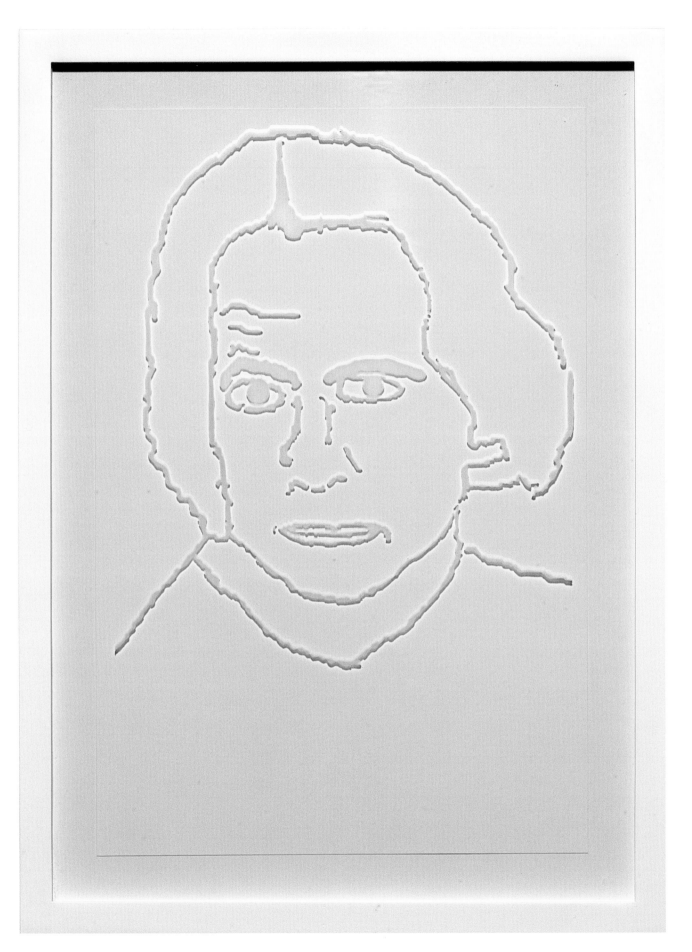

Philipp Hoschka

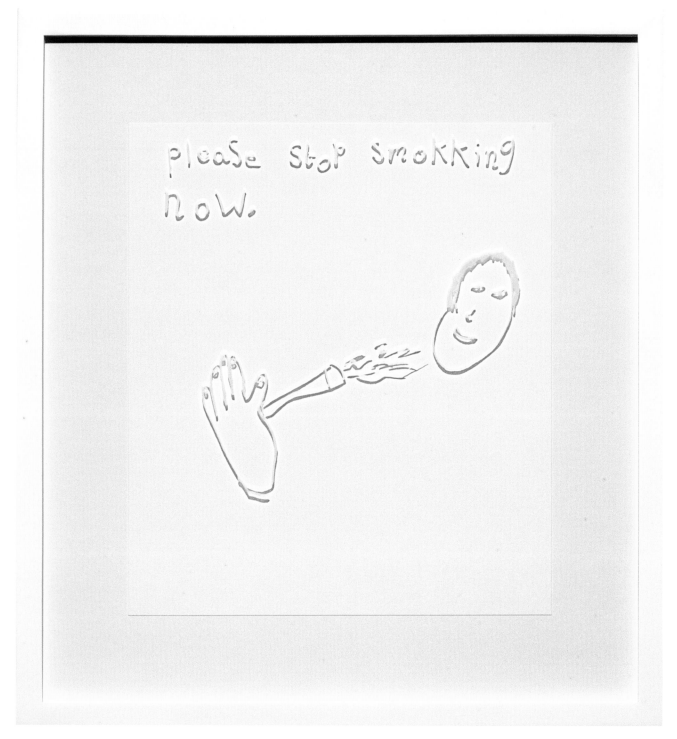

Common Occurrences, 2005
Please Stop Smokking

Common Occurrences, 2005
This is What Happens

OVERLEAF
Common Occurrences, 2005
Girl with Gun (detail)
Cyclone Attack (detail)

cyclone attack.

OPPOSITE AND FOLLOWING SPREAD

The Campaign for Rural England, 2006
› detail

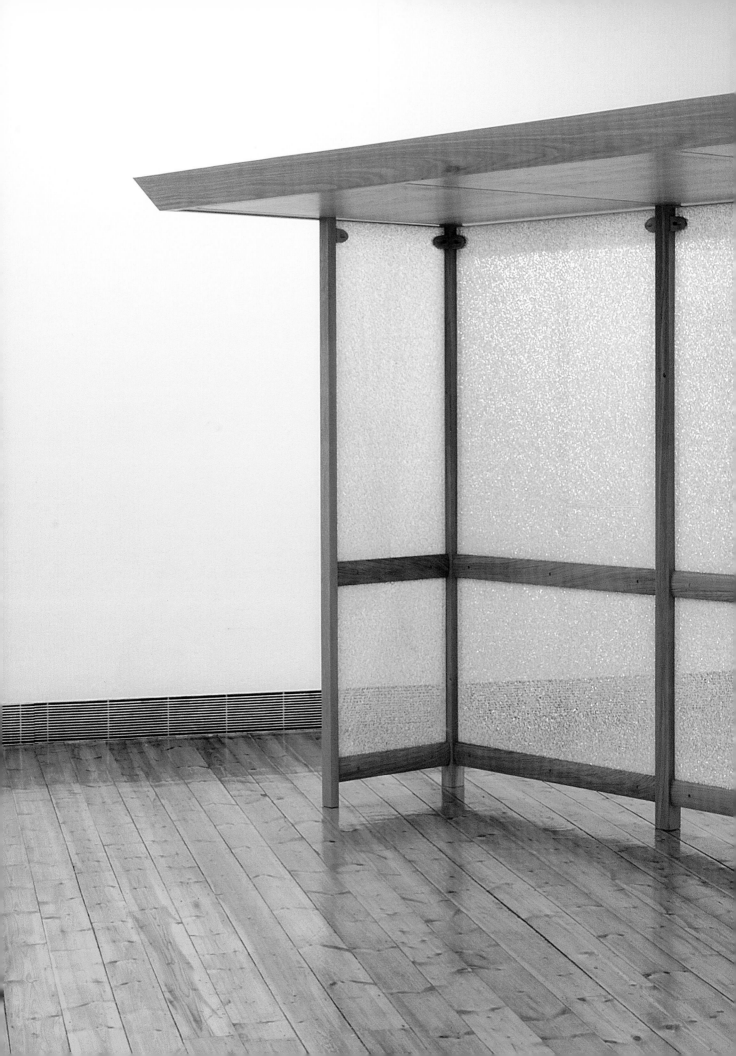

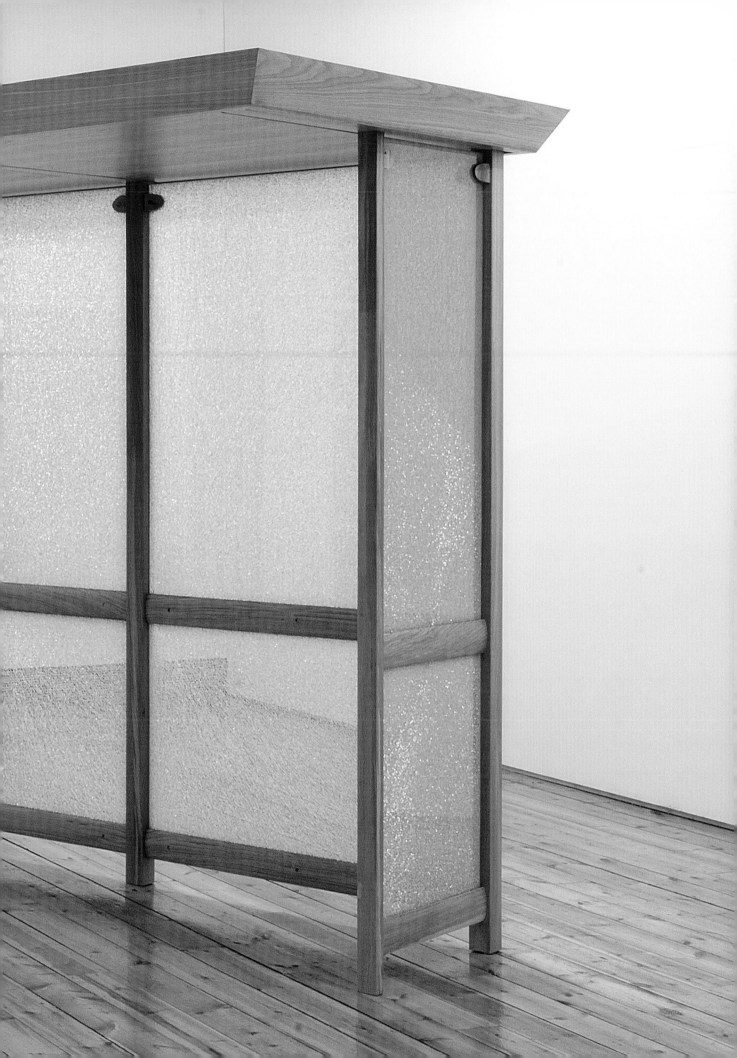

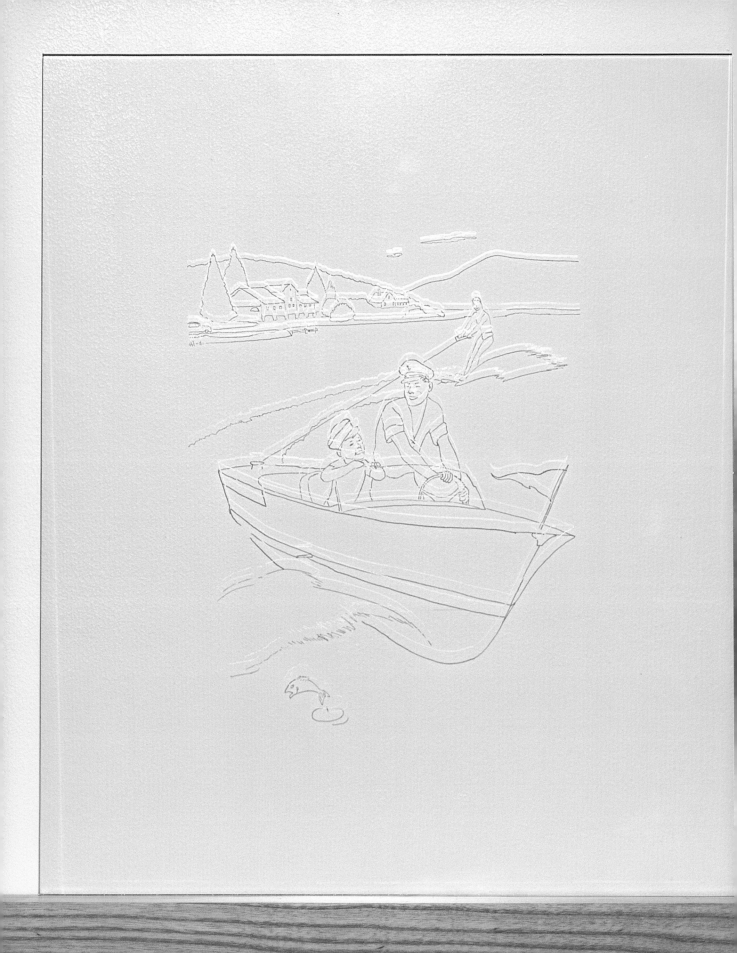

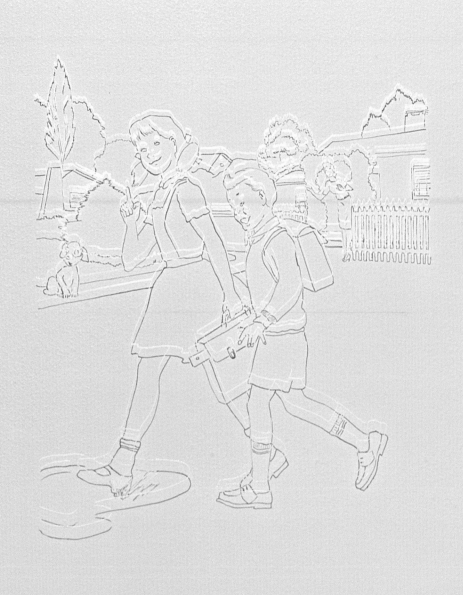

Zainab was a Human/Sulacion (H/S) hybrid and a devout Muslim. She was very active amongst the hybrid community that settled on Mars in the years after the first H/S contact and was one of the first H/S children to be successfully brought to term within a Martian biosphere. Her significance to the H/S community on Mars is all the greater for this fact.

Her father Ibrahim Samr Sadik was an engineer and mother Iptthrot Narntsab-wa Llthnnnztsol was a biochemist specialising in habitation management. They were responsible for founding a number of institutions on Mars, one of which – the Happy Mount nursery in New Karachi – still provides multi-species primary care to this day.

Zainab followed in her parents footsteps and was involved in numerous initiatives aimed at bettering the conditions for immigrant workers on Mars as well campaigning against hybrid discrimination – something she was, of course, acutely aware of. She was martyred on the 17 May 2226 (ESC) by a mob outside St Barnabas First Episcopal Church, Tomoroskiville. Her brutal murder took place after a public meeting set up to resolve trading disputes between Sulacion extraction companies and a cartel of independent indigenous traders. Typical of her unstinting and selfless work she had attended the meeting in a voluntary capacity and was providing translation clarification services during the meeting. After the meeting a group of Martian traders fell into an argument with one of the Sulacion delegates. Zainab attempted to separate the parties and was killed in the ensuing fracas.

OPPOSITE AND FOLLOWING SPREAD
The Family Tree of Zainab Duranthrrial Sadik Llthnnnztsol,
the First Martian Martyr, 2004

PREVIOUS SPREAD
Recent History, 2005 (details)

Abdul Majid Sadik = Shehnawaz Hussein
b.2004 - d.2092 b.2004 - d.2091

Salmana Ayisha Abdul Rashid Sadik = Nargis Sarawat Zainab
b.2025 - d.2157 b.2027 - d.2099 b.2034 - d.2110 b.2037 - d.2122 b.2044 - d.2126

Ahmad Sadik = Ayisha Al-Barbud Uthman Tariq
b.2056 - d.2157 b.2057 - d.2140 b.2060 - d.2062 b.2064 - d.2141

Umar Javid Ahmad Sadik = Ouda Shaki Nasseer Noor Ayisha
b.2073 - d.2092 b.2077 - d.2156 b.2081 - d.2157 b.2084 - d.2170 b.2087 - d.2170

Muhammad Sadik = Ammara Musharraf Abdullah Faisal
b.2103 - d.2194 b.2103 - d.2207 b.2107 - d.2118 b.2111 - d.2015

Abdul Kareem Abdul Rahman Sadik = Rakhalyd Naqq
b.2140 - d.2013 b.2136 - d.2261 b.2127 - d.2236

Ibrahim Sabir Sadik
b.2161 - d.2206

Zainab Duranthmal Sadik-Lithinnnztsol
b.2191 - d.2226

Nasseer
2081 - d.2157

Noor
b.2084 - d.2170

Ayisha
b.2087 - d.2170

f

Abdullah
b.2107 - d.2118

Faisal
b.2111 - d.221

Abdul Rahman Sadik = Rakhaiya Haq
b.2136 - d.2261 b.2127 - d.2236

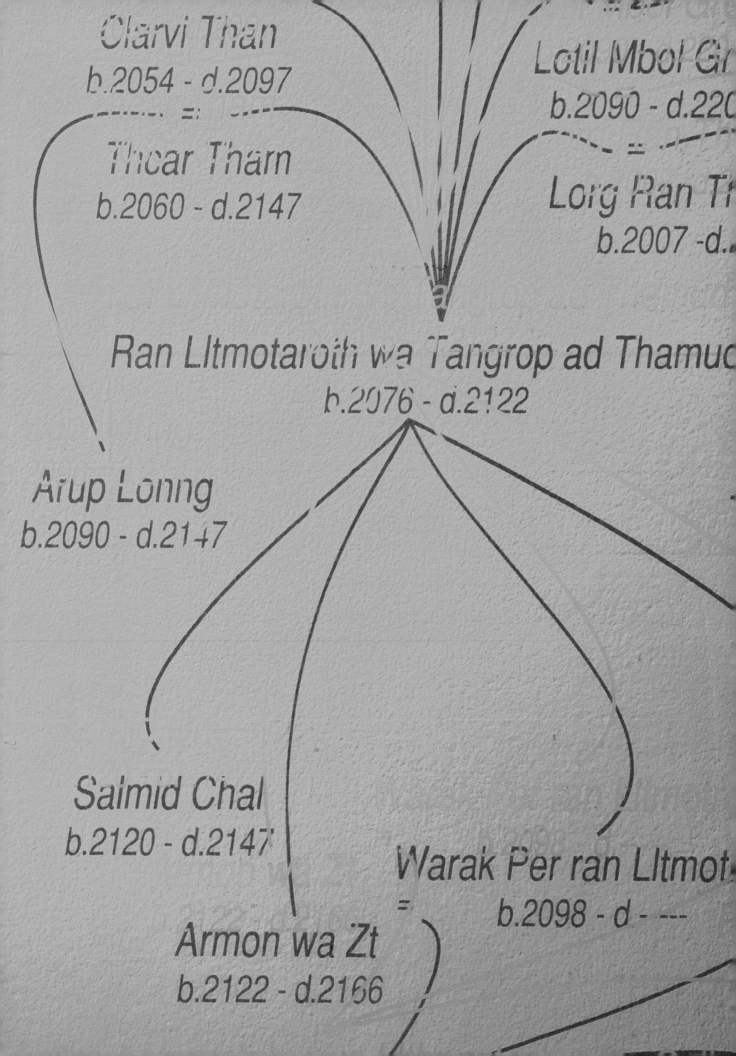

Clarvi Than
b.2054 - d.2097
=
Thear Tharn
b.2060 - d.2147

Lotil Mbol Gr
b.2090 - d.220
=
Lorg Ran Th
b.2007 -d.

Ran Lltmotaroth wa Tangrop ad Thamud
b.2076 - d.2122

Arup Lonng
b.2090 - d.2147

Saimid Chal
b.2120 - d.2147

Warak Per ran Lltmot
b.2098 - d ----

Armon wa Zt
b.2122 - d.2166

Memorial to the Red–Green Alliance, 2005

LAVAZZA

QUALITA' ROSSA

CONFEZIONE NON VENDIBILE
SINGOLARMENTE

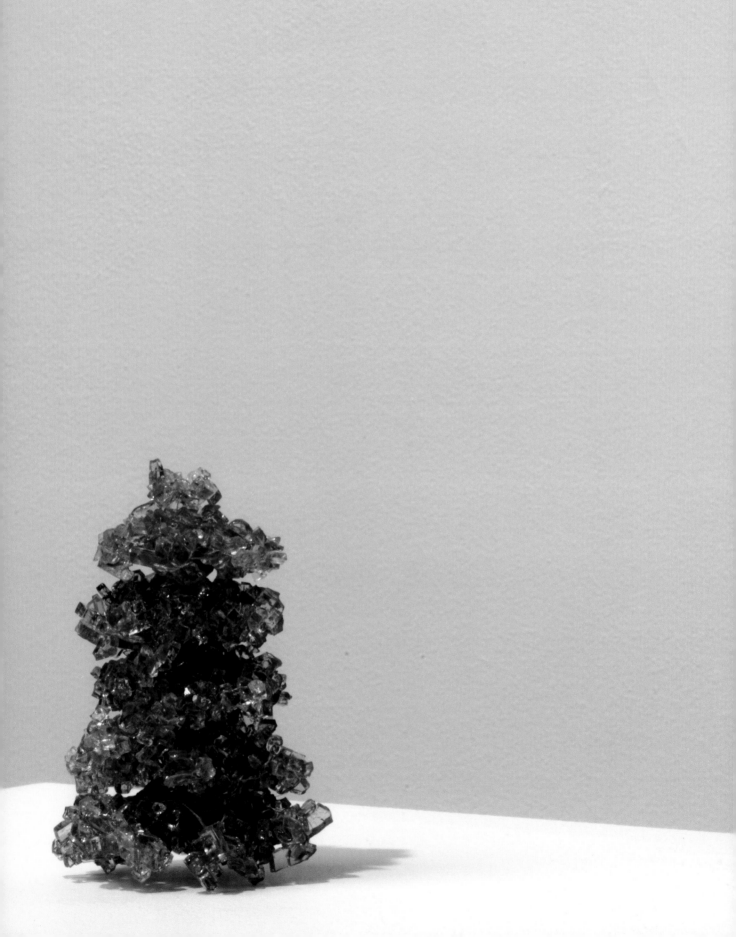

AT BOX IT IS SPYING

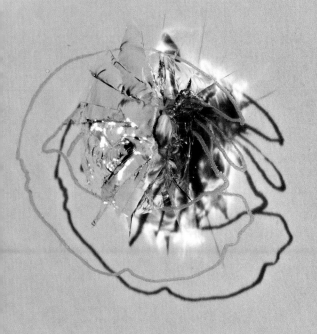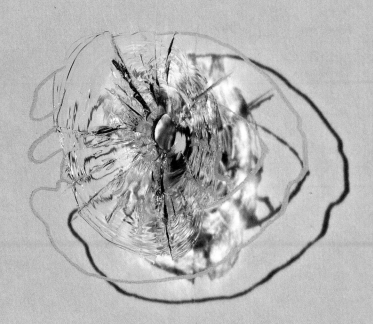

YOUR COMPUTER REMEMBERS ALL THAT YOU SEE

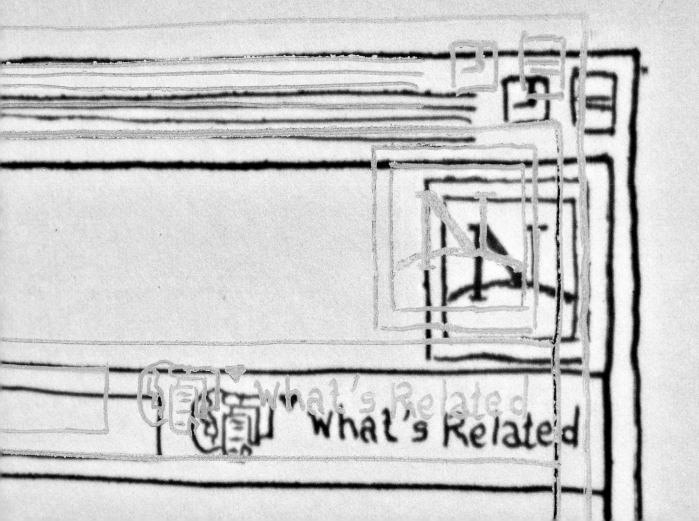

What's Related
What's Related

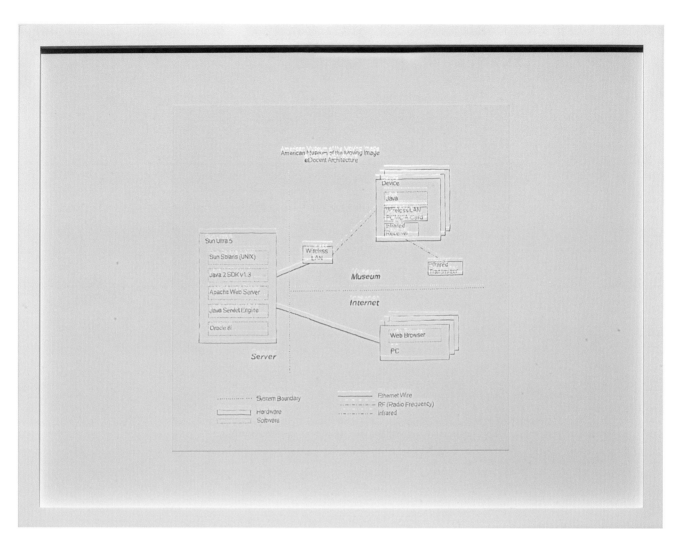

The Information Architecture of the American Museum of the Moving Image, 2004
> detail

PREVIOUS SPREAD

Oh Xmas Tree!, 2006
Computer Spy, 2005 (details)

American Museum of the Moving Image
eDocent Architecture

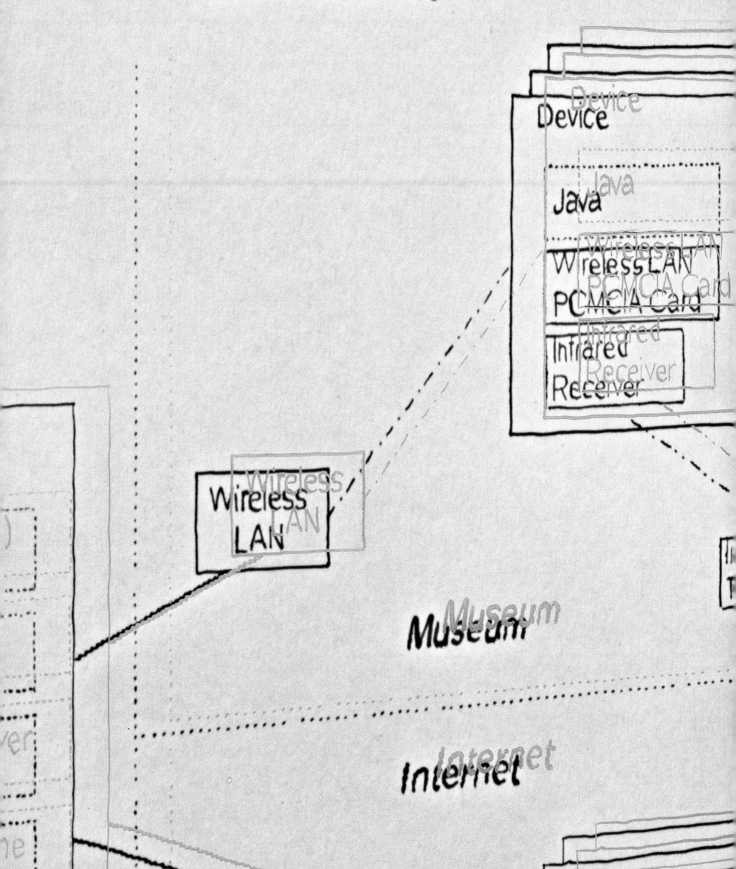

Device

Java

Wireless LAN
PCMCIA Card

Infrared
Receiver

Wireless
LAN

Museum

Internet

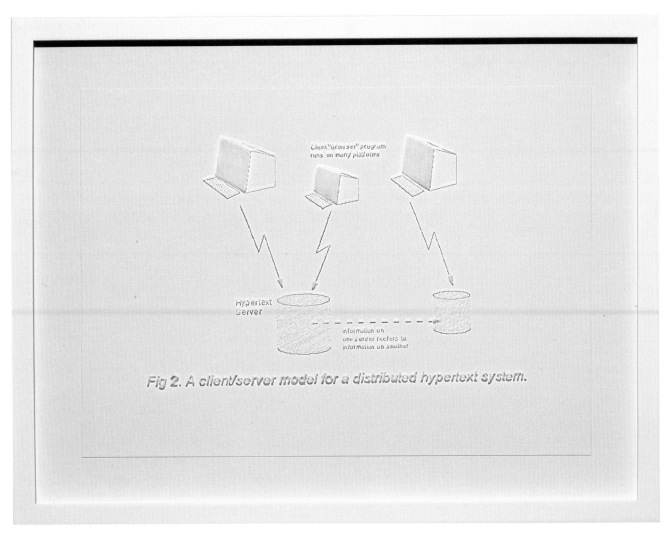

Fig 2. A client/server model for a distributed hypertext system.

Proposal for a World Wide Web, 2004
‹ detail

The Beheaded, 2006

76

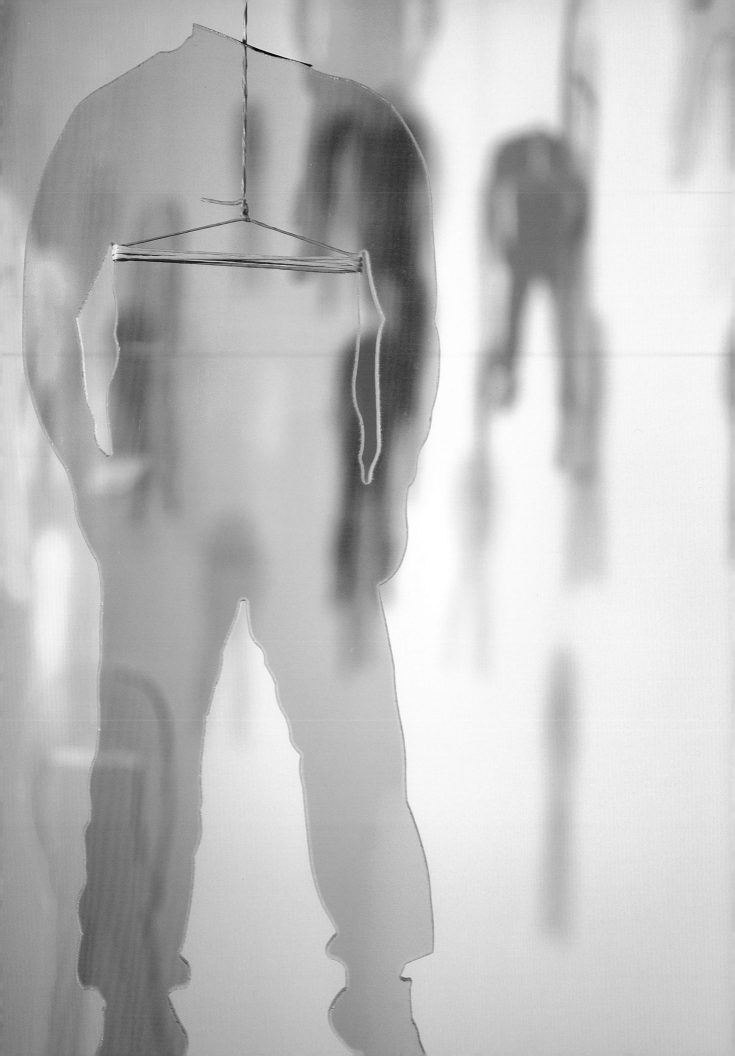

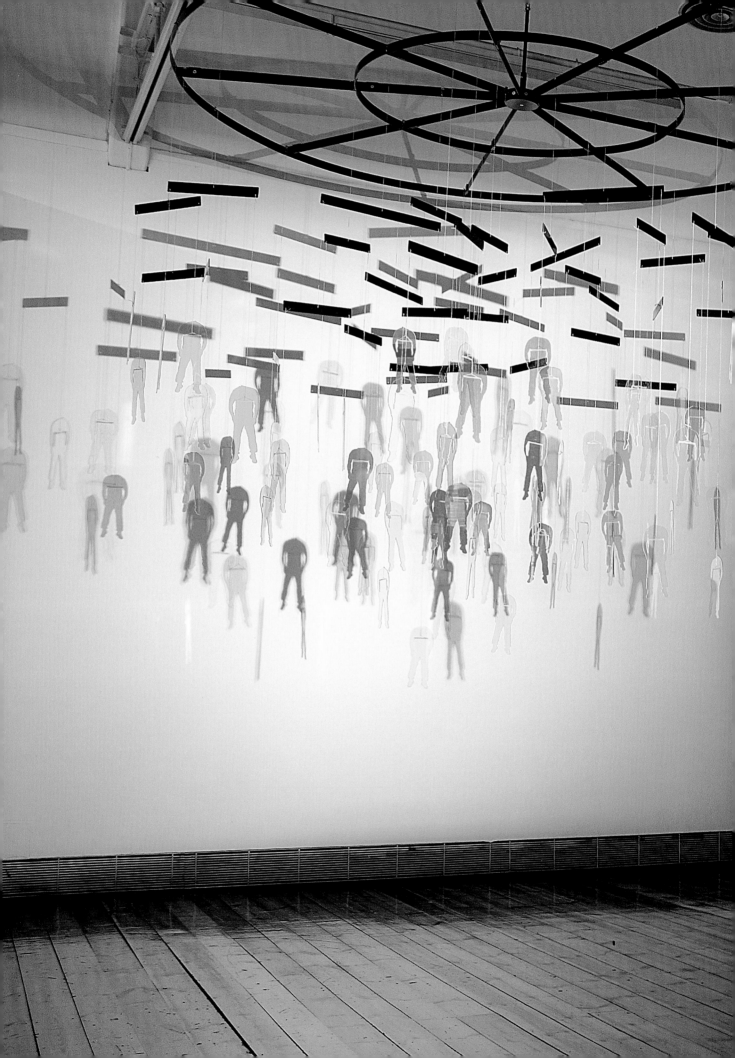

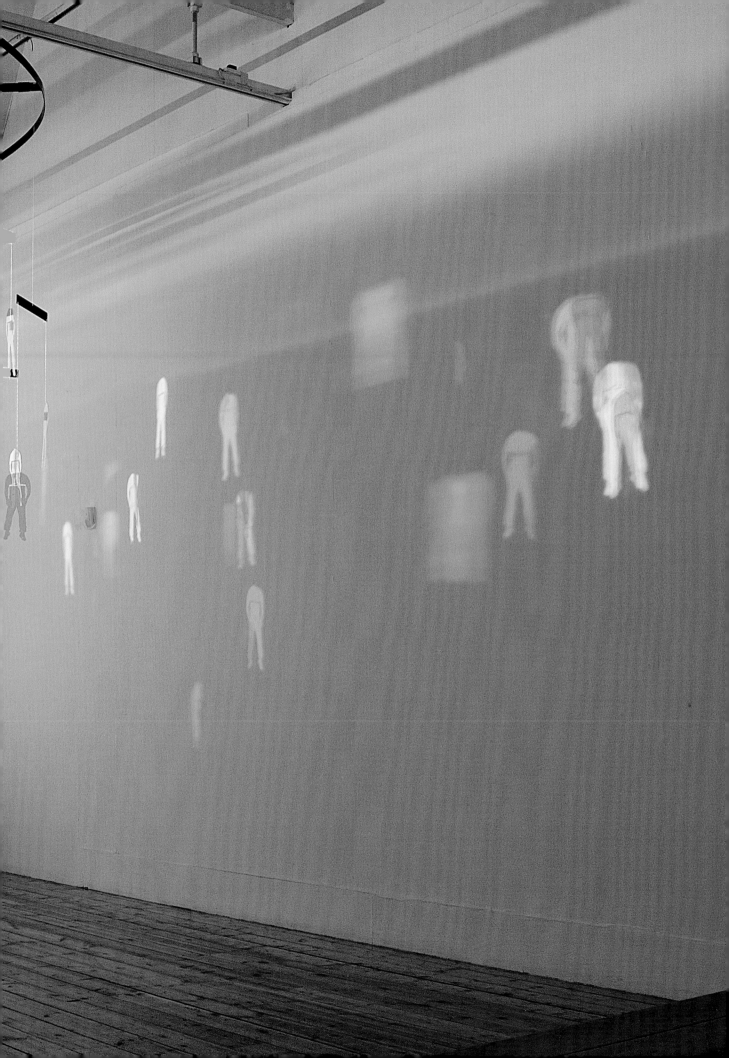

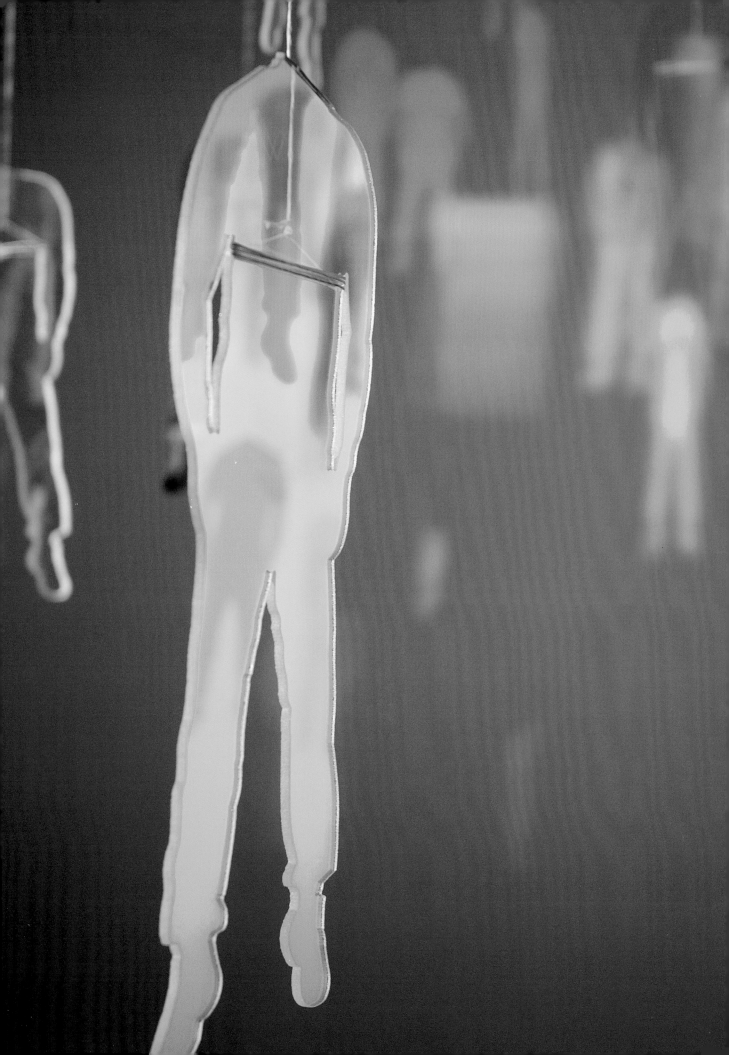

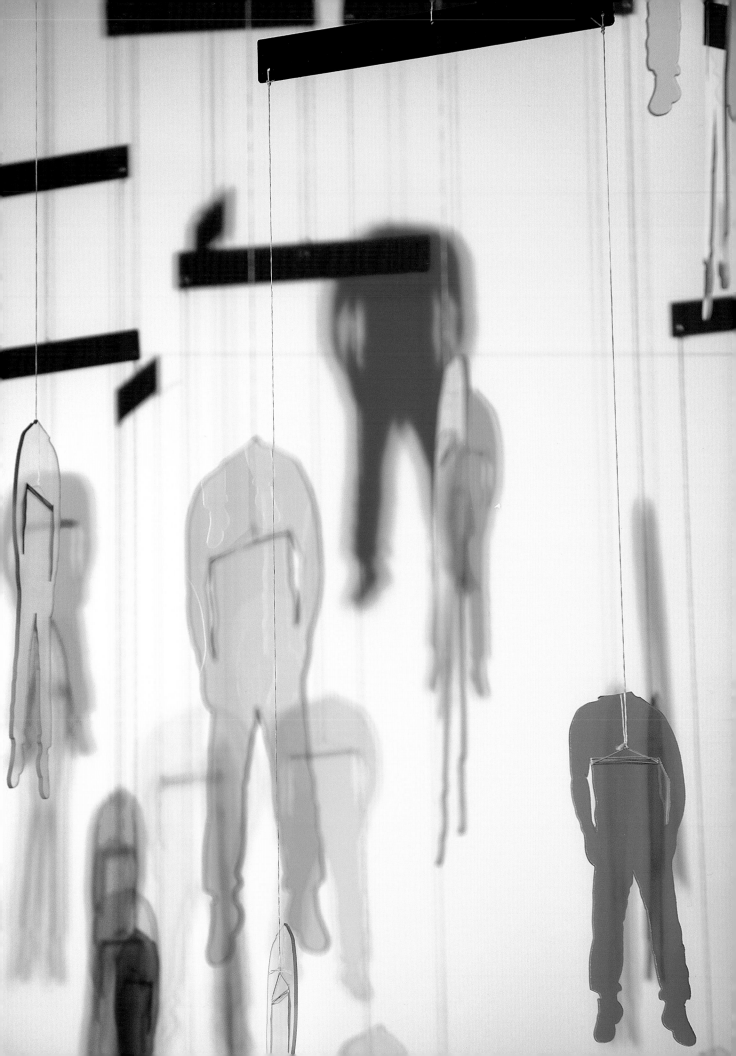

On Looking Back through
Sheets of Glass

MARCUS VERHAGEN

Glass is not on the face of it a promising material for an artist. It is difficult to work and easily damaged in transit. And it doesn't lend itself to photographic reproduction, as the closer it gets to perfect transparency the more nearly invisible it becomes. But for Nick Crowe, working in glass on the operations of memory, that near-invisibility is an asset, as it can stand as a parallel for the absence of the past to the recollecting mind. Most of Crowe's works in glass are in some sense commemorative objects, but they are unlike traditional memorials, which express, though their weight and durability, a resistance to forgetfulness. Crowe uses glass to etch the passing of time and failings of memory onto his commemorative objects, which become both memorials and anti-memorials, showing as they do that forgetting is an intimate part of remembering.

For the most part, Crowe turns to the recent past, as in *Three Cynical Objects – Nasdaq, FTSE, Dow* (2001), which looks at first sight like a set of tasteful corporate sculptures or trophies, objects that are made to sit on broad desks in sleek, glass-fronted office blocks. In fact, the work incorporates its implied setting, the wooden bases acting as metaphorical desks and the strips of glass as skyscrapers in miniature. Read it in this light and the objects convey, in their vertical thrust, an ethos of corporate striving and power, as in the old mantra 'the sky's the limit'. But the objects are also, it turns out, volumetric bar charts that trace the movements of three stock market indices, the NASDAQ, the FTSE 100 and the Dow Jones Industrial Average, during the turbulent period, from April 2000 to March 2001, that saw the bursting of the dot-com bubble. The objects may use the congratulatory rhetoric of the trophy, but they tell a dismal story of volatility and decline.

And they tell it in shades of green. In the making, glass is heated and poured in liquid form over a bed of molten tin, which cools it slightly and gives it a perfectly flat surface. The glass also contains iron which under certain lighting conditions, confers a green tinge, as it does here. Crowe hides a light in each base, illuminating the sheets of glass from below and bringing out a greenish glow in their surfaces and more particularly in their edges. The work plays on the associations of the colour: green is for 'greenback' – and for envy, as in Iago's warning in Othello against 'the green-eyed monster'. So the colour serves as another reminder of the heady speculation of the late nineties, of the venture capital that flooded into Silicon Valley and of the phenomenal growth in e-commerce and digital communications. But as so often in Crowe's work, the symbolism is double-edged. Industrial glass is green-hued but it is also fragile; and its fragility resonates here too. After all, companies that were the toast of Wall Street in 1998–99 suddenly looked vulnerable in 2000–01. Investors noted that many dot-coms were heavily indebted and that some had expanded massively without ever turning a profit. Then came the collapses and lay-offs and, most spectacularly of all, the accounting irregularities and bankruptcy of WorldCom. Crowe uses the properties and connotations of glass to point to both the boom and the bust and so to replay in a symbolic register the economic trajectory that is plotted in the bar charts.

82

That is not the end of it. Like the bubble of 'dot-com bubble', glass is transparent as well as fragile, and in a work that addresses the digital revolution that transparency reads as a gloss on cybernetic technology and on the economic developments that shadowed it. Glass is a substance that can withhold its materiality from view and as such it serves, in *Three Cynical Objects*, as an emblem of the streams of information and capital that travel invisibly between geographically remote positions. It is a cipher for the recent growth of industries that produce data rather than tangible goods and it calls to mind not just the virtual products but also the virtual fortunes that were made in Silicon Valley, where programmers and managers were often paid in stock options, many becoming paper millionaires and then seeing the value of their holdings dwindle as quickly as it had accrued.

The work is both a set of trophies and a modern vanitas piece. Like seventeenth-century Dutch and Spanish still life paintings of skulls, guttering candles and perishable fruit, which are now commonly interpreted as meditations on the transience of worldly pleasures, Crowe's piece sketches various professional satisfactions – a sense of corporate purpose, a well-furnished office and bank account – only to stress their impermanence. The objects bleed the pride from the trophy but they depart from the vanitas tradition inasmuch as they retain the trophy's commemorative function, its purchase on a specific moment. This collision of the trophy and the vanitas piece is what makes the work as funny as it is. Here as elsewhere, Crowe's pessimism is illuminated by a caustic, clear-eyed humour.

In other works too, Crowe uses glass to convey a sense of transience. Many of his works in glass draw on the internet, treating it not just as an economic instrument, as in *Three Cynical Objects*, but as a medium that rests on an intricate infrastructure and supports a vast array of new vernacular forms. In *Proposal for a World Wide Web* (2005), he reproduces the diagram that was used by Tim Berners-Lee in 1989 to outline the functioning of his proposed web. In *The Management Committee of the World Wide Web Consortium (w3c)* (2000), he presents low-resolution portraits, derived from tiny jpegs, of the thirteen regulators, including Berners-Lee, who set the standards and protocols that ensure the smooth operation of the web. These works and others like them offer insights on the cybernetic revolution, most of them gleaned from the web itself, Crowe's use of glass underlining the transparency of a resource that freely displays its own internal mechanisms but also the ephemeral quality of each datum that appears on the web, where it jostles with vast quantities of other data. Crowe surveys cyberspace from the perspective of the enthusiast who enjoys moving against the current, regularly referring to pages that expand on the infancy and workings of the web – pages that are easily overlooked in an ever-expanding, horizontal structure.

If works such as *Proposal for a World Wide Web* commemorate public facilities, other works in etched glass look to the web for memories of a more private order. *June Becher* (2003), for instance, is the hand-engraved reproduction of a message that was addressed by a woman to her deceased sister and posted on a website; the message is legible in the shadows cast by the engraved words on the paper behind the glass. The intersection of the mortal and the virtual is a common concern in Crowe's work and one that is regularly mediated, as in *June Becher*, by glass. The work encourages the viewer to see

an analogy between the medium and the text, the shadow and the shade: the thin, insubstantial appearance of the words as they fan out across the paper speaks to both the immateriality of cyberspace and the intangible presence of a remembered relative. And the aptness of glass as a vehicle for the woman's text comes across as a sign of empathy on the part of the artist. This too is a vanitas piece, but the tone has changed. As Crowe's perspective shifts from that of the investor or analyst in *Three Cynical Objects* to that of the internet surfer in *June Becher*, the corrosive wit gives way to a sympathetic probing of new expressive forms.

In some of his other works in glass, Crowe strikes a more hushed or quizzical note. This is true, for instance, of *The Beheaded* (2006), which shares the commemorative dimension of *Three Cynical Objects* and *June Becher* but takes a different tone, trippy and reticent. Headless figures, suspended from arms that are attached to a ceiling-mounted motor, form a giant rotating mobile, a kind of aerial merry-go-round. Here the transparency of glass lends the figures a spectral quality, as in Hollywood film and illustrated children's books, which regularly present ghosts and spirits as translucent characters – but Crowe gives the old pictorial simile a new spin. The figures are made of dichroic glass, which was developed by NASA for use in space suits and takes on a coloured gleam, the colour changing with the angle of vision; here the glass is by turns pink and green. The material is significant. It represents, with its micro-layers of metal oxides, a pitch of technological sophistication that is seemingly at odds with the ancient, ritualistic brutality of the beheading. The material jars with the image of the headless figure but the jarring serves a purpose: it drives home the continuing relevance of the imagery at a time when beheading is still practised across the globe – by Iraqi insurgents, Philippine terrorists, Colombian rebels and paramilitaries, and as recently as March 2005 by one axe-wielding man in North London. So the work can be understood as commemorating the men and women who have recently lost their lives in ritualised executions around the world.

The Beheaded is a memorial but it shies away from overt sentiment. Its decorative brilliance is also a turning away from intelligible consideration, almost a form of denial. Is that to distinguish it from the rhetorical context of the beheading, which is often accompanied by texts and speeches, by all the machinery of modern opinion-forming? Perhaps. Certainly, the work both opens up and short-circuits a number of interpretive possibilities. Inasmuch as it resembles the mobiles that hang over the beds of children, it can be understood as signalling a longing for distraction and consolation in a form that necessarily withholds them. In another, similarly infantile reading, the dichroic glass, with its connection to space travel, can be taken as hinting, in a childish kind of category error, that the souls of execution victims move in orbit around the earth, inhabiting the same space as the astronaut. Alternatively, the work can be seen as a latter-day *danse macabre*, but then it has none of the fierce, redemptive humour of the late-medieval imagery of the dance of the dead. These are readings that lead nowhere, that have no affective or explanatory force. It can be argued that every bid to interpret a violent act, however well-intentioned, will work to explain it and so to offer the beginnings of a defence. *The*

1 Significantly, the piece holds 68 figures in total. That number turns out to be a rough estimate of the number of people who have been beheaded in the twenty-first century..

Beheaded is a work that disables its own efforts to distil meaning from violence, preferring a dumbness that leaves the beheading to stand alone and the viewer to assimilate it in all its demented actuality.

Glass serves Crowe well as he revisits moments in the recent past, expanding on the power of memory but also on its failures and omissions, and on its detours, on the conduits that dam and divert it. The genesis of the web, the bursting of the dot-com bubble, the beheading of hostages in Iraq and elsewhere: Crowe reflects on these and other events and on the ways in which they are communicated and remembered, crossing the memorial with the financial report, the diagram and the web page. In the process, he paints a world traversed by vast data streams that use different codes and travel along different channels. As he lifts images and symbols from these streams, he works to undermine official truths and support vernacular expressions but also to confuse the codes, mapping the diagram onto the trophy, the vanitas image onto the web page, the *danse macabre* onto the space-age cut-out. Glass, in his work, allows for the coexistence of disparate messages, messages that combine to produce moments of illumination and passages of perverse humour. But the material, in its fragility and transparency, also opens the work to absence, immateriality and death, and then the disparate messages produce lapses and non sequiturs, a kind of silent log-jam. In Crowe's world, silence is, it would seem, at the core of remembrance.

Nick Crowe: Commemorative Glass
Exhibition Checklist

All works courtesy the artist unless otherwise noted
Dimensions unframed: width/height/depth

The Campaign for Rural England, 2006
English oak sculpture, with three-layer, 15 mm laminated toughened safety glass (cracked and bonded)
410 × 240 × 160 cm
pp. 58–61

The Beheaded, 2006
Ceiling-mounted mobile with armatures of powder-coated mild steel, suspending 68 elements cut from 3 mm dichroic glass with Kevlar thread
3.2 m aerial circumference with 2.8 m drop
pp. 76–81

Oh Xmas Tree!, 2006
UV-bonded automotive glass sculpture
8 × 11 × 8 cm
p. 70

27 Damaged Windscreens, 2006
Edition: 1 of 5
DV to DVD 'slideshow' of images sourced from a Google search for 'damaged windscreens'
Sound: Super Furry Animals, 'Ice Hockey Hair' from torrent file 'Mash up the CIA'
5 min 17 sec
p. 88

Operation Telic, 2005–2006
Twelve shelves with inset hand-engraved drawings on 2 mm float glass panels, cast plastic and electrics
Distributing Aid (6 panels) 180 × 40 cm *p. 30*
Thumbs Up (4 panels) 140 × 40 cm *p. 19*
Soldiers Talking to Women (4 panels) 140 × 40 cm
pp. 19, 30
Visiting Schools and Hospitals (4 panels) 120 × 40 cm
pp. 16, 26
Soldiers Doing War (4 panels) 120 × 40 cm *pp. 32–33*
Soldiers Doing Civil Order (4 panels) 120 × 40 cm
p. 31
Soldiers with Children (4 panels) 120 × 40 cm
pp. 28–29
Soldiers Talking to Men (2 panels) 80 × 40 cm *p. 26*
Soldiers and Their Guns (2 panels) 80 × 40 cm
(not illustrated)
Groups From Above (2 panels) 80 × 40 cm *p. 27*
Kids Looking Through Sights (2 panels) 80 × 40 cm
p. 20
Medical Aid (2 panels) 80 × 40 cm *p. 31*

Common Occurrences, 2005
Five hand-engraved drawings on 4 mm float glass
This is What Happens 49 × 38 cm
Please Stop Smokking 46 × 50 cm
Girl with Gun 46 × 35 cm
Cyclone Attack 44 × 23 cm
Nathan's Ship 42 × 35 cm
pp. 54–57

Memorial to the Red–Green Alliance, 2005
Lavazza Rosso packet, electrics and smashed automotive glass sculpture
10 × 18 × 6 cm
pp. 68–69

Computer Spy, 2005
Hand-engraved drawing on 4 mm float glass
with bullet holes
60 × 45 cm
p. 8, p. 71

Recent History, 2005
Five hand-engraved drawings on 4 mm float glass
39 × 46 cm each, on a 240 × 15 × 4.5 cm shelf
pp. 62-63

*The Family Tree of Zainab Duranthrrial Sadik Llthnnnztsol,
the First Martian Martyr*, 2004
Machine-engraved drawing on 8 mm float
glass, lit by a rotating coloured disco light, with
accompanying brushed stainless steel text panel
150 × 150 cm with a 60 × 39 cm text panel
pp. 64-67

*The Information Architecture of the American Museum of
the Moving Image*, 2004
Hand-engraved drawing on 4 mm float glass
60 × 45 cm
pp. 72-73

Proposal for a World Wide Web, 2004
Hand-engraved drawing on 4 mm float glass
60 × 45 cm
pp. 74-75

June Becher, 2003
Edition: 1 of 3
Hand-engraved drawing on 4 mm float glass
60 × 45 cm
pp. 8, 36-37

Three Cynical Objects – Nasdaq, FTSE, Dow, 2001
Three UV-bonded float glass sculptures set in
white American ash
19 × 53 × 19 cm
pp. 42-43

*The Management Committee of the World Wide Web
Consortium (W3C)*, 2000
Edition: 2 of 3
Thirteen hand-engraved portraits on 6 mm
float glass, in hanging order left to right: Daniel
Weitzner, Janet Daly, Jean-François Abramatic,
Daniel Dardailler, Nobuo Saito, Dan Connolly,
Tim Berners-Lee, Vincent Quintt, Alan Kotok,
Judy Brewer, Tatsuya Hagino, Josef Deitl,
Philipp Hoschka
39 × 54 cm each
pp. 44-52

Additional works illustrated (not in exhibition)

Margo Barbour's Web Site, 1998
Hand-engraved drawing on 6 mm float glass
180 × 30 cm
p. 4

A Glass Menagerie, 2001
Hand-engraved 6 mm float glass sculpture
55 × 21 cm
Private Collection
p. 34-35

The New Medium (detail), 1999
Fifteen hand-engraved drawings on 6mm float
glass
60 × 45 cm
p. 39

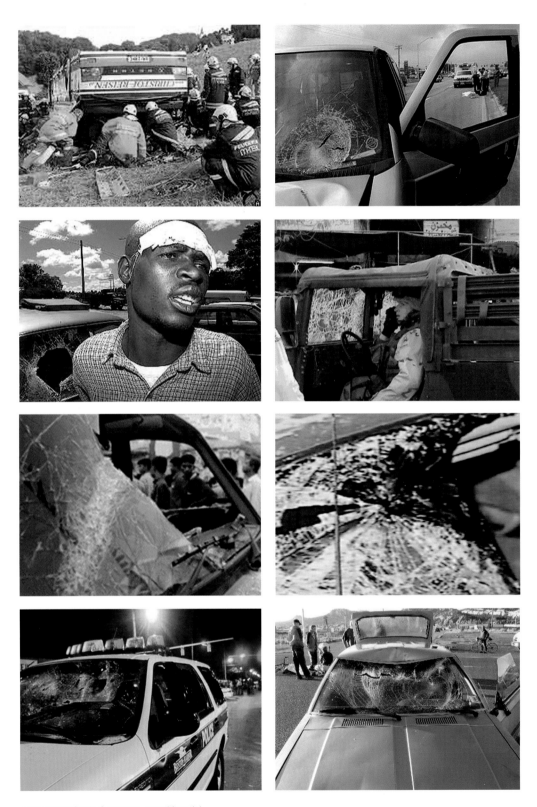

27 Damaged Windscreens, 2006 (details)

88

Biography

Nick Crowe
Born 1968 Barnsley
Lives Manchester and Berlin

Selected Solo Exhibitions

2006

Commemorative Glass, Cornerhouse, Manchester
and tour (catalogue)

2005

Operation Telic, con|temporary, Berlin

2003

The Nineties, Mobile Home, London

Getting On, Chisenhale Gallery, London

Nick Crowe and Ian Rawlinson, Manchester Art
Gallery and tour (with Ian Rawlinson) (catalogue)

Police Radio, FACT, Liverpool and ICA Media
Centre, London

2002

Explaining Urbanism to Wild Animals, Tmesis Gallery,
Manchester (with Ian Rawlinson)

2001

Nasdaq Landscape, Yorkshire Sculpture Park,
Wakefield

2000

Stuff with Glass and Light, Chapter, Cardiff

The New Medium, Lux Gallery, London

1998

The Ten Point Plan for a Better Helsinki, Muu Media
Festival, KIASMA, Helsinki (catalogue)

1997

Mugger Music, Lower Manhattan Cultural Council,
New York (with Graham Parker and Ian Rawlinson)

1996

Mugger Music, Manchester International Arts,
Manchester (with Jane Gant, Graham Parker and
Ian Rawlinson)

1995

Xmas 1998, Nottingham Castle Museum and Art
Gallery, Nottingham (with Index)

1994

The Alphabet of Dogs, Oliver Machine Works,
Manchester (with Index)

Train Up a Child in the Way He Should Go, Holden
Gallery, Manchester (with Index)

Selected Online Projects

2006

YouTube Videos
http://www.youtube.com/nickcrowe

2005

Bertholtbrechtdotcom
http://www.nickcrowe.net/online/
bertholtbrechtdotcom/

2003

Police Radio, commissioned by FACT, Liverpool
http://www.policeradio.org.uk

The World Wars, commissioned by Becks Futures,
London http://www.the-world-wars.co.uk

2002

Artones, commissioned by The-Phone-Book,
Manchester http://www.artones.net

Different AVs, commissioned by Film & Video
Umbrella and Channel 4, London
http://www.nickcrowe.net/online/differentavs/
diffavs.html

2000

SERVICE2000, 29 uncommissioned websites
http://www.nickcrowe.net/online/service2000_
7of29/archive

Discrete Packets, commisoned by DA2 for
VideoPositive2000
http://www.nickcrowe.net/online/discretepackets

1999

Y2K - The Relationship between Faith and Technology,
commissioned by The Waiting Rooms
http://www.nickcrowe.net/online/y2k

1996

One Day and All of the Night Online, commissioned by
ArtAIDS, London
http://www.nickcrowe.net/online/oneday

Selected Group Exhibitions

2007

Ni Hao, The Gallery of Central Academy of Fine
Arts, Beijing and tour (catalogue)

2006

Revolution is not a Garden Party, Trafó Gallery,
Budapest and tour

Mind the Gap, Smack Melon, DUMBO, Brooklyn

2005

Parallel Projects, 9th International Istanbul Biennial,
Istanbul (catalogue)

There is Always an Alternative, TemporaryContemporary,
London and tour (catalogue)

2004

FILE04, Festival of Electronic Media, Sesi Gallery,
São Paulo

Romantic Detachment, PS1, New York and tour
(with Ian Rawlinson)

Futrology, New Art Gallery, Walsall (with Ian
Rawlinson) (catalogue)

After Life, Bowes Museum, County Durham
(catalogue)

Futureways, De Vleeshal, Middelburg, (catalogue)

2003

Manchester Portfolio, London Print Studio, London

Becks Futures, ICA, London and tour (catalogue)

Thermo 3, The Lowry, Manchester

Post-It, Floating IP, Manchester and tour

2002

Sambond / Connections, Institute of Culture and Fine
Art, Hafnarborg

Once Again, John Hansard Gallery, Southampton
(with Ian Rawlinson)(catalogue)

6/6, Ibid Projects, London

Travelogue, Whitworth Art Gallery, Manchester
(catalogue)

Atmosphere, Manchester Art Gallery, Manchester
(with Ian Rawlinson)

Reactions, Exit Art, New York

2001

A Fair Place, Nouvelle Peripheries, Museum of
Contemporary Art, Istanbul

The Digital Aesthetic, Harris Museum & Art Gallery,
Preston

Record Collection, International3, Manchester and tour

Digital Visions, Lovebytes 2001, Showroom Cinema,
Sheffield (catalogue)

Ich Bin, 2YK Gallery, Berlin
(with Ian Rawlinson)(catalogue)

Short Stories, La Fabricca del Vapore, Milan
(catalogue)

Nick Crowe & Kenny Hunter, Turnpike Gallery, Wigan

2000

In Memoriam, New Art Gallery, Walsall (catalogue)

Look and Feel, Büro Friedrich, Berlin (catalogue)

Double Feature: Nick Crowe & Gary Hill, SFMOMA,
San Francisco

net.congestion, De Baile, Amsterdam (catalogue)

Goethe's Oak Has Woodworm, Static Gallery, Liverpool

Endings, Whitworth Art Gallery, Manchester

Bono & Sting Inhabit Lowry's Living Room, FROM SPACE, Salford

SpaceCraft, VideoPositive2000, Liverpool (catalogue)

Exploding Cinema: Cinema Online, Rotterdam International Film Festival, Rotterdam (catalogue)

1999

Museum Magogo, Glasgow Project Space, Glasgow and tour

MART, Centre for the Understanding of the Built Environment, Manchester (with Ian Rawlinson) (catalogue)

VirtualTour, Museo de Monterrey, Monterrey

Life is Good in Manchester, Celeste and Eliot Kunstsalon, Zurich

1998

What Difference Does it Make?, Cambridge Darkroom Gallery, Cambridge

Artranspennine98, Tate Liverpool and Henry Moore Institute, Leeds (with Graham Parker and Ian Rawlinson) (catalogue)

1997

Sarah Staton's Supastore, Cornerhouse, Manchester and tour

Connected, Northern Gallery of Contemporary Art, Sunderland

Tutor with an Idea, Three Month Gallery, Liverpool

Urbanites, City Racing, London (with Graham Parker and Ian Rawlinson)

Home Ideals, FAT, London

Young Parents, Castlefield Gallery, Manchester (with Martin Vincent)

20/20, Kingsgate Gallery, London and tour

1996

Town (seen with a straight back), The Annual Programme, Manchester

BANK TV, ICA, London and tour

1995

Soft Rock, Silesian Museum, Katowice (with Index)

Ha!, 10a Little Peter Street, Manchester (with Index)

Other Activities

2004–2007

The Internationaler, Editorial Board (with Dave Beech, Paulette Brien, Rachel Goodyear, James Hutchinson, Mel Jordan, Laurence Lane, David Osbaldeston, Becky Shaw and Martin Vincent) Liverpool, Manchester and Sheffield

2004–2007

Art and Media Arts Research Centre, MIRIAD, Manchester Metropolitan University

Research Fellow with an AHRC award for 'The Aesthetic and Conceptual Possibilities of Industrial Glass Processing Techniques in Contemporary Visual Art'

2003

Artranspennine03, co-curator (with Ian Rawlinson) Archived at: www.artranspennine.org.uk

2001–2005

The Manchester Pavilion at the Venice Biennale. Co-founder (with Paul Bayley, Pavel Büchler, Graham Parker and Martin Vincent)

1995–2000

The Annual Programme, Manchester, co-director (with Martin Vincent)

1989–1995

Index Theatre Co-operative, a collective performance and installation group (with Paulette Brien, Adele Fowles, Jane Gant, Julian Hammond and Graham Parker)

Bibliography

Nick Crowe: Published Projects

The Reporters of the BBC Website (Zurich/Berlin: The Green Box, 2006)

'Artist Pages' (with Ian Rawlinson) in *Urban Memory: History and Amnesia in the Modern City*, edited by Mark Crinson (London: Routledge, 2005)

'The Curator Awakes', in *Futureways* (New York: Arsenal Pulp Press/Whitney Museum of American Art/Printed Matter Inc., 2005)

'Kyoto Protocol' (with Ian Rawlinson), *Flux Space, Flux Magazine* (Manchester), August-September 2001

The Citizens (London: Artec/Book Works, 1999) http://www.nickcrowe.net/online/citizens/index.htm

'The Day the Internet Disappeared (MM, interracial)', *Crash Media* (Manchester), June 1998

'Something the Museum Sent Us' (with Index), *Versus Contemporary Art* (Manchester), Issue 5, 1996

Selected Books and Monographs

Howes, Natasha (ed.), *Nick Crowe & Ian Rawlinson* (Manchester: Manchester City Art Gallery, 2003), texts by Dave Beech, Rachel Withers and Mika Hannula

Huffman, Kathy Rae (ed.), *Nick Crowe: Commemorative Glass* (Manchester: Cornerhouse, 2007), texts by Esther Leslie, Godehard Janzing and Marcus Verhagen

Kimbell, Lucy (ed.), *New Media Art: Practice and Context in the UK 1994-2004* (London/Manchester: Arts Council England/Cornerhouse, 2004)

Paul, Christiane, *Digital Art* (London: Thames & Hudson, 2003)

Reitmaier, Heidi, 'Up for Grabs: Narrative and the Net', in *Supermanual* (Liverpool: FACT, 2001)

Stallabrass, Julian, *Internet Art* (London: Tate Publications, 2003)

Selected Reviews

Autio, Milla, 'Uimassa Toolonahdella', *Helsinki Sanomat*, 8 October 1998

Beech, Dave, 'Independent Collaborative Hospitality', *VARIANT*, Volume 2, Number 22, Spring 2005

Beech, Dave, 'Santiago Sierra, Stephen Willats, Swetlana Heger, Roland Boden, Nick Crowe', *Art Monthly*, October 2002

Black, Paul, 'Certifiable Art', *FlashArt*, October 2002

Chrisafis, Angelique, 'Manchester Rising', *The Guardian*, 5 January 2001

Clark, Robert, 'Xmas 1998', *The Guardian*, 9 June 1995

Cooper, Emmanuel, 'Mobility Allowance', *Ceramic Review*, 4 July 2003

Crinson, Mark, 'Explaining Urbanism to Wild Animals', *MUTE*, Issue 29, February 2005

Darwent, Charles, 'Dying is an Art and They Do it Very Well', *The Independent on Sunday*, 10 December 2000

Dawson, Mike, 'Nick Crowe and the Annual Programme', *FLUX Magazine*, Issue 5, April 1998

Etchells, Tim, 'Index Theatre', *frieze*, 20, January-February 1995

Gibbs, Michael, 'Networking', *Art Monthly*, September 2002

Gibbs, Michael, 'Gallery Detours', *Art Monthly*, October 2000

Guyton, Marjorie Allthorpe and Glinkowski, Paul, 'Solid Foundations', *Tate Magazine*, Winter 2000

Hefland, Glen, 'Digital Folk Artist Nick Crowe Subverts Human-Web Interaction', *SF Gate*, 31 October 2000

Kohn, Marek, 'Up Close and Personal', *The Independent on Sunday*, 21 March 1999

Lack, Jessica, 'Nick Crowe and the Merseyside Police Hitlist', *The Guardian*, 6 October 2003

Lack, Jessica, 'Artranspennine03', *The Guardian*, 26 May 2003

Lapp, Axel, 'Ich Bin', *Art Monthly*, September 2001

Lyall, Sutherland, 'Site Name Taken? No Problem - Just Join the Dots', *The Architects' Journal*, Volume 212, Number 16, 2 November 2000

McKean, Andrea, 'Young Parents', *MAKE*, 76, May-June 1997

Mulholland, Neil, 'Artranspennine03', *frieze*, Issue 79, November-December 2003

Nesbitt, Rebecca Gordon, 'Urban Myths', *contemporary visual arts*, Issue 17, Spring 1998

Parker, Graham, 'Go West Young Man', *Art Monthly*, December-January 2001

Parker, Graham, 'The Other Side of Zero', *Art Monthly*, May 2000

Perez, Alex, 'From the Web to Eternity', *Business 2.0*, 6 March 2001

Rawlinson, Ian, 'Mugger Music (Walking the City)', *InterELIA Magazine*, Issue 2, Winter 1996

Reitmaier, Heidi, 'Artzone', *Tate Magazine*, Issue 24, Spring 2001

Reitmaier, Heidi, 'Mugger Music', *Sculpture*, Volume 17, Number 1, January 1998

Robertson, Mick, 'The Ghost in the Machine', *FLUX Magazine*, February 2003

Schoellhammer, Georg, 'The User Takes All', *Springerin*, December-January 2001

Simpson, Ronnie, 'Life is Good in Manchester', *Art Review*, December-January 2001

Stone, Rob, 'Tight Shoes and the Lump-Cut (Walter's Embrace)', *Coil #5*, Autumn 1997

Thomson, Jon, 'Alter e-galleries', www.eyestorm.com, 25 June 2000

Thomson, Jon, 'Anthropology.net', *Art Monthly*, April 1999

Verhagen, Marcus, 'Nick Crowe', *Art Review*, September 2003

Vincent, Martin, 'Futurology - The Black Country 2024', *The Future*, Issue 1, September 2004

Nick Crowe: Critical Writing

'Unplanned Articulation', *Convergence: The International Journal of Research into New Media Technologies*, Volume 12, Number 2, 2006

'Leo', *The Internationaler*, Autumn 2005

'Their Dark Materials', in *Galanty* (Manchester: i3 Publications, 2005)

'Erika Tan', *Art Monthly*, April 2005

'The Big Fat Pipe Dream: The Challenges of the Internet as a Site for Artistic Creativity', in *The Artist's Handbook* (London: Thames and Hudson, 2005)

'Pavel Büchler', *Art Monthly*, September 2004

'Irwin', *Art Monthly*, April 2004

'Hotlist', *Art Forum International*, Summer 2003

'Band Wagon Jumping', *Art Monthly*, December-January 2003

'Dean Hughes', *Art Monthly*, April 2002

'Janette Parris', *Art Monthly*, February 2002

'Constantly Falling Rocks', in *Life is Good in Manchester* (Manchester: Trice Publications, 2001)

'Parallel Lines', in *Work and Leisure International* (Manchester: Trice Publications, 2000)

'Websites', *AN Magazine*, October 2000

'Project for the River Medlock' (with Ian Rawlinson), *Landlines - Landscape Design Journal*, December 1998

'Isea 98', *Artists' Newsletter*, September 1998

'Collaboration' (with Ian Rawlinson), *Artists' Newsletter*, May 1998

'Connections', *Artists' Newsletter*, December 1997

'Babes in Technoland', *MAKE*, 76, June-July 1997

Catalogue Contributors

GODEHARD JANZING | Godehard Janzing is an art historian, with special expertise and interest in monuments and the military. The scientific collaborator for the Deutsches Historisches Museum's project 'Kunst und Propaganda', Janzing is currently working on a dissertation, 'Reception of Antiquity and Military Reforms in Visual Arts around 1800: Schadow, David, Goya'. He is an editor for the e-journal kunsttexte.de and for the academic online network *H-ArtHist*. Janzing's publications include 'National Division as a Formal Problem in West German Public Sculpture: Memorials to German Unity in Münster and Berlin', in Charlotte Benton (ed.), *Figuration/Abstraction: Strategies for Public Sculpture in Europe 1945–1968* (Ashgate Press, 2004), and 'Le pouvoir en main: Le bâton de commandement dans l'image du souverain à l'aube des Temps modernes', in Thomas W. Gaehtgens and Nicole Hochner (eds), *L'image du Roi de François Ier à Louis XIII* (Paris: Editions de la Maison des Sciences de l'Homme, 2006). http://www.gjanzing.de/

ESTHER LESLIE | Dr Esther Leslie is a cultural critic, writer and Reader in Political Aesthetics at Birkbeck, University of London, in the School of English and Humanities. Her research interests are in Marxist theories of aesthetics and culture, with a particular focus on the work of Walter Benjamin and Theodor Adorno. Other research interests include European literary and visual modernism, the 'everyday' and value, memory and history, madness and expression and digital aesthetics. Her books are *Synthetic Worlds: Nature, Art and the Chemical Industry* (Reaktion Books, 2005), *Walter Benjamin: Overpowering Conformism* (Pluto, 2000), and *Hollywood Flatlands: Animation, Critical Theory and the Avant-Garde* (Verso, 2002). She is actively involved in editing three journals: *Historical Materialism: Research in Critical Marxist Theory*, *Radical Philosophy* and *Revolutionary History*. http://www.bbk.ac.uk/eh/staff/acStaff/LeslieEsther

MARCUS VERHAGEN | Marcus Verhagen studied art history at Cambridge University and received a PhD from the University of California, Berkeley. He is a freelance writer, critic and curator working on issues including utopianism, life and death and the organisation of the art world. He is a tutor at Sotheby's Institute, and lectures at the Ruskin School of Art, Oxford University, and at the Chelsea College of Art and Design. He has also taught at the University of London, the University of Manchester, the University of California, Berkeley, and Mills College, Oakland. Verhagen's criticism of art, artists and performance has appeared in numerous recognised art journals including *Modern Painters*, *Art Monthly*, *frieze*, *contemporary* and *Art Review*. He has lectured at Tate Modern, ICA London, the Royal College of Art, the Victoria & Albert Museum, the Whitechapel Art Gallery, and the Architectural Association in London. He has independently curated exhibitions in London and Berlin.

KATHY RAE HUFFMAN | Kathy Rae Huffman is Visual Arts Director at Cornerhouse. She received an MFA in Exhibition Design from California State University, Long Beach, where she also completed the graduate course in Museum Studies. She has held curatorial posts at the Long Beach Museum of Art and the ICA Boston, and has freelanced. She has written about, consulted for, and coordinated a variety of international and online events. Her research continues to focus on issues of female online environments, and the history of video and interactive television as art. She co-founded FACES (with Diana McCarty and Valie Djordjevic), an international online community for women artists. Her internet project work with Eva Wohlgemuth is archived online. Huffman's recent curatorial work includes *Marcel Odenbach: The Idea of Africa* (2005); *Zineb Sedira: Telling Stories with Differences* (2004); *Grace Weir: A Fine Line* (2003); *and Lab3D – Web 3D Art* (2003). http://www.faces-l.net/

Acknowledgements

I would extend my thanks to those individuals who have variously inspired, supported and assisted in the production of this work over the past few years, including Trevor Barber, Martha Crowe, Nathan Crowe, Holger Frieze, Jude Goodwin, Andrea Hawkins, Kathy Rae Huffman, James Hutchinson, Mona Jas, Axel Lapp, Rita McBride, Francis McKee, Jim Medway, Nadia Molinari, Gregor Muir, Ian Rawlinson, Glen Rubsamen, Matthew Shaul, Jon Traynor, Benjamin Weil, Ania Witkowska and Rutger Wolfson. I'd also like to thank my colleagues at MIRIAD, Manchester Metropolitan University and particularly Pavel Büchler, Neil Grant, John Hyatt and Dan Nuttall, who have supported my work as a researcher in the faculty – a project of which this exhibition is one outcome. Finally I'd like to thank the various suppliers and fabricators who have assisted in the production of the work: Nigel Stretton and Andy Pointer at Technical Materials Converters, Macclesfield; Jonathon Buck and Luke Burgess at Bradford Woodworkers, Bradford; Simon Gue at Warm Glass Ltd, Bristol; Andrew Taylor and Jonathan Taylor at Specialist Glass, Huddersfield; Steve Jeffrey at Jeffrey Douglas Bespoke Joinery, Manchester; Gary Noton at ST Design and Manufacturing, Stalybridge; Bob Meen at Batmink, Glastonbury; Mark Darbyshire at Darbyshire's Fine Art Framers, London; and the support team at Bentley Chemicals, Kidderminster.

I would also like to thank the staff at Cornerhouse as well as the writers who have contributed to this catalogue: Esther Leslie, Godehard Janzing and Marcus Verhagen; and David Williams for his careful and painstaking photography of the work.

Nick Crowe

Cornerhouse Staff

Dave Moutrey, Director

Management Team

Isabelle Croissant, Marketing Director
Paul Daniels, Publications Director
Jennifer Jones, Finance Director
Kathy Rae Huffman, Visual Arts Director
Linda Pariser, Cinemas Director
Sarah Perks, Education Director
Pat Raikes, General Manager

Visual Arts Team

Rebecca Hill, Visual Arts Organiser
 (maternity leave)
James Hutchinson, Exhibition Coordinator
Rebecca Keating, Visual Arts Assistant
Tereza Kotyk, Visual Arts Organiser
 (maternity cover)
Helen Wewiora, Media Curator
Katherine Woodfine, Galleries and Bookshop
 Manager

Gallery Invigilators

Robert Bailey
Alexander Bird
Kelly Burgess
Evanthia Grigoropoulou
Benjamin Gwilliam
Andrew Hancock
Sarah Hardacre
Duncan Hay
Ebony Jones
Gary Leddington
Jamie MacDonald
David Martin
Anne Sellers
Richard Shields

Visual Arts Technicians

Andrew Bracey
Rob Carr, Airbox
Evanthia Grigoropoulou
Richard Kendrick
Gary Leddington
Tim Machin
Roger Quigley
Maeve Rendle
Otto Smart
Jonathan Trayner

Cornerhouse Staff Contributors

Alison Avery, Tom Jeffers, Andy Murray,
 Front of House Managers
Debbie Bell, Cleaning Supervisor
Chris Clarke, Publications Officer
Jennifer Crowley, Press Officer
John Dennis, Development and
 Fundraising Officer
Alistair Morton, Maintenance Manager
Charlotte Pedley, Marketing Officer
Deyan Raykov, IT and New Media Officer
Aruna Seth, Finance Officer
Siobhan Ward, Administrator
Lesley Young, Visual Arts Education Officer